# ESCHER on ESCHER

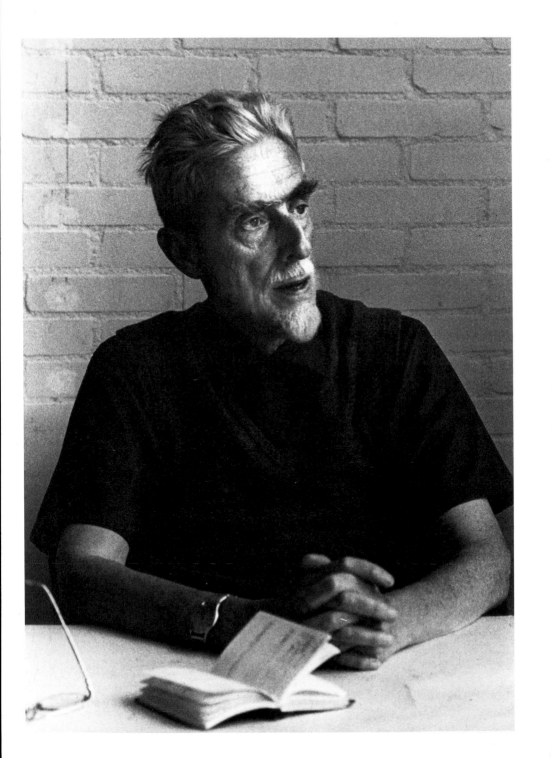

# ESCHER on ESCHER
## EXPLORING the INFINITE

M.C. ESCHER

With a contribution by J. W. Vermeulen   Translated from the Dutch by Karin Ford

HARRY N. ABRAMS, INC., Publishers

*Compilation:* W. J. van Hoorn and F. Wierda
*Editor, English-language edition:* Janet Wilson
*Designer, English-language edition:* Judith Michael

*Front cover: Symmetry Work 21.* 1938. Ink, pencil, and watercolor,
13 × 9½". Collection Charles and Evelyn Kramer, Israel Museum, Jerusalem
*Frontispiece and back cover:* Photograph of M. C. Escher

The original works by M. C. Escher reproduced on pages 26 (left),
27 (right), 28 (left), 69 (right), and 88 are in the collection of Michael
S. Sachs Inc., P.O. Box 2837, Westport, Connecticut 06880

Originally published under the title *Het oneindige*

*Note:* This book follows the format used by Escher in his slide lectures.
He cited specific works by title, as well as details from other prints
for which titles were not given.

LIBRARY OF CONGRESS CATALOGING-IN-PUBLICATION DATA

Escher, M. C. (Maurits Cornelis), 1898–1972.
Escher on Escher.

Translation of: Het Oneindige: M. C. Escher over eigen werk.
1. Escher, M.C. (Maurits Cornelis), 1898–1972
—Philosophy. I. Vermeulen, J. W. II. Title.
NE670.E75A35 1989 769.92'4 88-8185
ISBN 0–8109–2414–5 (pbk.)

*Printed and bound in Japan*
20 19 18 17 16 15 14 13

Harry N. Abrams, Inc.
100 Fifth Avenue
New York, NY 10011
www.abramsbooks.com

Abrams is a subsidiary of

LA MARTINIÈRE

# CONTENTS

# RATIONALE

Another book about Escher. Is that really necessary? Yes, in our opinion. The book is necessary because one important expert on Escher's work has said far too little until now: Escher himself. It is true that in *Grafiek en tekeningen (The Graphic Work of M.C. Escher)* he has given an overview of his work in broad strokes. *De werelden (The World of M.C. Escher)* includes a treatise by him about the infinite. *Leven en werk (M.C. Escher: His Life and Complete Graphic Work)* contains quotes from letters and lectures, as well as the text of his book *Regelmatige vlakverdeling (The Regular Division of the Plane)*. But he has left us a lot more material.

—During the 1940s and 1950s Escher wrote in magazines that were read only by his colleagues.

—Over time he gave a large number of presentations about his work, frequently illustrated by slides. The text of all those presentations — some general, others about a specific aspect of his work — has been preserved.

The publisher, as well as the Escher family and their representative, agreed with us that this unknown or barely known material should not be withheld from the tens of thousands of people interested in his work, who are to be found throughout the world.

We also considered the hundreds of thousands of people who — often not that long ago — have come under the spell of Escher's wondrous world but do not possess all that has been published by and about him. With that in mind, we have tried to create as complete an image of that world as possible.

In order to reach this goal, we have made a careful selection from the previously mentioned unknown material. We have added two other texts by Escher: the article "Approaches to Infinity," from *De werelden van M.C. Escher (The World of M.C. Escher)*, and the complete text from the collector's edition *Regelmatige vlakverdeling (The Regular Division of the Plane)*, which is also a part of *Leven en werk van M.C. Escher (M.C. Escher: His Life and Complete Graphic Work)*.

This last book — the standard work about Escher — in fact includes a number of passages from lectures and articles that have been made an integral part of *Escher on Escher: Exploring the Infinite*.

# THE ORGANIZATION OF THIS BOOK

The selected material has been divided into several sections.

The first section, entitled "Artist or Graphic Artist?" consists of four texts. Together they provide a solid image of Escher as he saw himself, not as an "artist" but an artisan, a graphic artist with heart and soul, obsessed by contrasts.

The second section is entitled "The Lectures That Were Never Given." In 1964 Escher was scheduled to present a series of lectures in the United States. He had beforehand, as was his habit, written a complete text of the lectures. At the very last moment, however, the trip was canceled when he had to undergo emergency surgery at a hospital in Canada. Consequently, the lectures were never given.

The two lectures that Escher was to present at a convention in Lexington, Massachusetts, are particularly interesting. Together they give an overview of the entire body of Escher's work. We have included the complete texts, including the one hundred slides, in pairs, that Escher had intended to show. All the time and effort he spent on the preparation of these lectures has therefore not been wasted.

The third section, "Four Hobbies," contains texts discussing in greater depth the most important subjects touched upon in the "American" lectures: the regular division of planes, approaches to infinity, perspective, and the impossible.

*Escher on Escher: Exploring the Infinite* concludes with an essay by Jan W. Vermeulen, who was Escher's business representative for a long time. In "A Subjective Portrait" he gives his own vision of the man Escher whom he knew personally. Vermeulen's view of the artist certainly does not agree with ours in all areas, but in our opinion his essay presents a worthwhile contribution to discussions about the intriguing personality of Maurits Cornelis Escher.

The Editors

Quote from a letter by M.C. Escher to his son Arthur, November 12, 1955.

Good God, I wish I'd learn to draw a little better! How much effort and persistence it costs to try to do it well. Every once in a while the stress of it all drives me to the point of a nervous breakdown. It is really strictly a matter of persisting tenaciously with continuous and, if possible, pitiless self-criticism. I believe that to produce prints the way I do is almost strictly a matter of wanting so terribly much to do it well. Talent and all that are really for the most part just baloney. Any schoolboy with a little aptitude can perhaps draw better than I; but what he lacks in most cases is that tenacious desire to make it reality, that obstinate gnashing of teeth and saying, "Although I know it can't be done, I want to do it anyway."

In 1950 a discussion took place between the illustrator Oey Tjeng Sit and the graphic artist M.C. Escher. The argument was whether there are any essential differences between the viewpoint of illustrators on the one hand and graphic artists on the other. The discussion took the form of an exchange of letters, published in the *Newsletter of the Dutch Circle of Graphic Artists and Illustrators.*

In his first letter Escher was still willing to talk about the viewpoint of the graphic artist, but begged off in his second letter. He found it more interesting to philosophize about the lack of evolution in the plastic arts, noting that such artists always have to start out on their own, carrying over nothing essential from their predecessors. This is a viewpoint that characterizes Escher the individualist. He felt that as an "artist" he had absolutely no one to turn to but himself. And, as can be seen in his letter, he assumed that the same applied to other artists.

However, Escher was a graphic artist in heart and soul. Not only was he the complete master of his craft but, owing to the importance he attached to contrasts, he also preferred working with graphic techniques. These contrasts are discussed in a subsequent article (again mostly philosophical) in the club newspaper, *De Grafische (The Graphic Arts).*

Did Escher consider himself an artist? He philosophized about this question in his speech accepting the Hilversum Culture Prize in 1965. No, he concluded. Not an "artist," but a graphic artist, "with heart and soul."

# 1

## ARTIST OR GRAPHIC ARTIST?

# THE CRAFT

From *Newsletter of the Dutch Circle of Graphic Artists and Illustrators*, no. 5, December, 1950.

Les Eyzies                                                              August 1, 1950

Dear Oey,

I am writing while seated in a small meadow on the banks of the Vézère, a tributary of the Dordogne from which this French province derives its name. Across from me, on the other bank, limestone rocks rise up with perpendicular walls, some of which are like cliffs and easily eighty meters high in some places. These rocks separate the fertile river valley from the arid highlands, which are densely overgrown with thickets and thorny bushes. In those perpendicular limestone walls are many caves and hiding places in which people have lived since time immemorial, some of which even now are inhabited. The difference between then and now is that cement facades, sometimes painted in bright colors, with doors and windows, close off their dwellings.

I have just read again your letter in which you further explain your point of view as an illustrator and, to tell you the truth, I don't very much feel like discussing that again. This means perhaps a sad end to our discussion. I hope, however, that some of our colleagues will bring it back to life again by disclosing their individual or group point of view. As far as I am concerned, I feel more like telling you something about what has fascinated me most during the two weeks I am spending here. Please forgive this sudden jump; in a way, there is a connection with your argument.

In the environs of Les Eyzies, the village that is sometimes called "the capital of prehistory," I visited a large number of caves. Some contain only marvelous stalactite formations, with no indications that in ancient times they were ever entered by human beings. I do not want to talk about these marvels of nature, which are often spectacularly illuminated by electric light, but about those others that have walls and vaults with a natural surface suitable for scratching or painting figures, and on which one

finds images of animals observed by the human eye a good 20,000 years ago (according to modern scientific methods of determining time periods geologically, much older still—between 70,000 to 100,000 years ago). One of those caves, Lascaux, rediscovered only recently (in 1940) and open to the public since 1948, contains by far the most beautiful and best-preserved paintings of the entire region. One sees there, in splendidly rich and clear shades of black, auburn, and ocher, a great number of animals. These are horses, cows, bulls, deer, bison, wild goats, a rhinoceros, a bear, and a wolf, close together, often painted one over another, on various scales (from bulls of more than five meters in length down to little horses of less than twenty centimeters scratched into the limestone). They have made an overpowering, breathtaking impression on me.

You get such a strange feeling when you try to imagine what is meant by "70,000 years ago." You try to imagine it, but can't. How short is a historical period of 5,000 years, from the oldest Egyptian pyramids until today, compared with that time span! A dark night lasting perhaps twenty times longer than that entire historical period separates us from the human spirit whose mirror image we observe on the walls of this cave. It is an image that is alert, lively, and that speaks to us immediately, as if it had been painted yesterday. It touches you deeply, not so much at the moment you are observing it (I didn't see anyone in our group bursting into tears), but later on, now, that is, while I am sitting here on the grass. Yes, it is a strange phenomenon that human spirit, that unextinguished spark, that seed that remained alive, the thread we hold in our hands that connects us, across the soundless and pitch-black night, with this member of our species there in the cave of Lascaux, dimly illuminated by a small wick dipped in animal grease and set in a hollow stone. Do you see him sitting there, our brother? What does he look like? What kind of sounds come out of his mouth? Does he stammer a language? We don't know. But we do know, we do see something else. A brush or a tuft of animal hair or of plant fibers is in his hand, and with it he brushes over the rough surface of the stone. Look! The head of a bull appears on the rock wall, an image so alive that it looks as if it moves. It looks as if the damp nostrils tremble. Our brother depicts the bull with such intense emotion that the distance of 700 or 1,000 centuries that separates us from him shrinks to nothing. What do we care how he looks; isn't he our very own brother? What does it mean when we call him "primitive"? Is he really inferior to us? Can we do things "better" than he? Does it clearly appear that we are "farther along" than he was? Have the Great Ones whom we honor, the mighty sculptors from any of the historical periods, depicted life more sharply, with more intensity than he has?

He did not have paper and pencil for sketching, no modern well-lighted drawing table on which to make preliminary sketches. It must have been tiring to bend over his work while painting an animal five meters long clear across the vault of his cave. While

painting such an animal under the poor lighting conditions at his disposal, he perhaps could not see the head as he was working on the hindquarters. But his will and his capacity to produce pictorial images were at the least just as strong as ours. Perhaps even stronger because he was in direct contact with nature, which we usually approach by way of a cultural and educational system that, if not barring the way, certainly obstructs it for us.

The plastic arts have not experienced an evolution. In everything else that man makes and in much of what he thinks, he adds his contribution to what has been done by previous generations. In everything he strives toward perfection. The development of his spirit and his increasing mental grasp are staggering in all aspects—except in the plastic arts. It seems to me that here each individual has to start from scratch each time, without ever taking anything of really primary importance from a predecessor.

I am coming to that conclusion now that I have seen the prehistoric frescoes of Lascaux. The question is whether this conclusion is correct. Why shouldn't I happily accept the contrary if it's shown to me based on reasonable grounds?

Dear Oey, I have to go back to my little hotel, where I shall drink a glass of delightful local wine to your health, and I send my kindest regards.

M.C. Escher

# OUR BROTHER

From *Newsletter of the Dutch Circle of Graphic Artists and Illustrators*, no. 3, June, 1950.

Baarn, April 26, 1950

Dear Oey:

It seems inevitable that when an illustrator and a graphic artist are each defending their viewpoints they will misunderstand each other. In my response to your interesting letter, it won't be possible for me to avoid that. Even worse, I shall unfortunately have to give a subjective answer to your beautiful, objective exposition. You have come to the wrong address with your request because I can't possibly give you a reply "in the name of the graphic arts," and you will have to be satisfied with my personal opinion.

You expect, if I understand you correctly, that I will give you reasons for the point of view that illustrations aren't acceptable as autonomous manifestations of art but only as interim stages, something like an illustration compares to a graphic print as a caterpillar compares to a butterfly.

Yes, I can more or less accept that line of reasoning. The graphic artist's goal is to produce graphic art. When he needs preliminary sketches in order to reach that goal, he will draw them, generally with a pencil on paper. Consequently his work consists of two distinctly separate stages, preliminary sketches first and development into graphic prints second. (It has become apparent to me from conversations and remarks of my colleagues who are graphic artists that certainly not everyone works in this manner, but I repeat that I cannot help being subjective.) Illustrations are consequently for the graphic artist (mostly) an indispensable link in the chain of his activities, but never his goal. That is probably the reason why a graphic artist cannot suppress a feeling of dissatisfaction when presented with an illustration as end result. You see, I don't give reasons, only statements. This feeling of uneasiness on the part of the graphic artist

with respect to illustrations has nothing to do with esthetic appreciation. It is obvious that a sketch, for example, a preliminary sketch for an etching, can be more "beautiful" (more spontaneous, more on target, freer, you name it) than the etching itself, and that we therefore sometimes prefer to see the preliminary stage rather than the end result at an exhibition. But aren't we talking strictly about the goal the artist sets for himself?

How could we possibly ever blame an illustrator for not getting "beyond" an illustration? Let him continue to do what he does. He has my blessing. However, it is another matter that I find it hard to imagine he is satisfied with it.

I have a feeling that this letter is now going to deteriorate into singing the praises of the excellence of graphic techniques. I knew it would happen; so be it.

What is really so fascinating about graphic processes? What is that strange power of attraction that keeps its hold on the graphic artist, which is the reason he specializes to such an extent that, as a rule, he does not engage in any other form of art? There are, I believe, three elements that are an inherent part of this fascination:
1. desire for multiplication
2. beauty of the craft
3. forced limitations resulting from the technique

The possibility and the desire for multiplication, which the illustrator does not know and in which the graphic artist can indulge to his heart's content, is often considered the preeminent characteristic of graphic art. It is clear that an illustration, being by nature unique, therefore contains an element of dissatisfaction for the graphic artist. That remarkable urge to obtain multiple images, for which I have no rational explanation, probably goes back to a primeval instinct. It has something to do with "Go forth and multiply" (nowadays one could add, also with regard to graphic art, "but be on your guard for overpopulation").

As far as the craft is concerned, I know of course that for the creation of any image whatsoever the hand is the miraculously refined tool, the intermediary between spirit and matter. But the illustrator doesn't know anything about what we graphic artists call "the craft" —the struggle with the unmanageable material, the process of conquering a hostile material resistance, which the wood-carver and the engraver do know (more or less in the way the carpenter knows it), and I feel sorry for the illustrator because he is thus deprived of a great joy.

The restrictions finally forced upon us by graphic techniques (and those of wood-carving are probably the most rigid of all) are unknown to the illustrator. He can of course restrict himself, but he does not have to. The graphic artist, however, must (at least if he wants to keep from violating his material). He perhaps even chooses his technique because he consciously wants to set himself very definite limits, because he prefers discipline above the seduction of multiplicity and chaos. In fact, simplicity and order are, if not the principal, then certainly the most important guidelines for human

beings in general. The urge toward simplification and order keeps us going and inspires us in the midst of chaos. Chaos is the beginning; simplicity is the end. The above-mentioned element of repetition and multiplication is *not* in conflict with this. On the contrary, order is repetition of units; chaos is multiplicity without rhythm.

Have I answered your letter now? I'm afraid I haven't, but it certainly gave rise to these outpourings, and I hope that they will satisfy you.

I was captivated by the passages in your letter in which you talk about the intellectual concept of form relationships in a black-and-white illustration and about color in connection with abstraction, but I won't start a discussion about these with you. I hope that these, especially the latter subject, will be taken up "from an abstract viewpoint" in a future issue of our newsletter.

Best regards,
M.C. Escher

# WHITE—GRAY—BLACK

From *De Grafische (The Graphic Arts)*, no. 13, September, 1951.

To the extent that we don't get involved with colors, we graphic artists and illustrators live and work by the grace of all the infinitely many shades that lead from the most extreme white to the most extreme black. This is a thought that keeps recurring to me and that I shall try to develop further here.

The boundaries within which we operate— "snow" white paper and "pitch" black paint or chalk or printer's ink—remain of course physically far removed from the absolute white and black. However, these are the materials we have, and we seldom feel that the strongest contrast that the material allows us is too weak for the goal we want to reach. It is, in fact, already a considerable leap, and usually we even prefer contrasts that do not extend as far as our most extreme possibilities allow.

But however accomplished, it is the contrast that we are after.

We human beings are always after contrast, and without contrast in a more general sense life is impossible on our solid ball of earth, which, revolving around its axis, floats so happily through infinite space in spite of all human blunders. Do you see it, basking in its mother's light, patient and faithful to the law that dominates it, floating through the pure emptiness? I often see it, a touching and majestic sight, at night before I go to sleep. But back to the matter at hand.

Life is possible only if the senses can perceive contrasts. A "monotonal" organ sound that is held too long becomes unbearable for the ear, as does, for the eye, an extended solid-color wall surface or even a cloudless sky (when we are lying on our backs and see neither sun nor horizon). It seems, so I have been told, that the following torture

was practiced by the people of an ancient culture: the head of a prisoner who was to receive punishment was tied immovably in place in such a way that his eyes could not observe anything other than an evenly lit, smooth, white-plastered wall surface (one can possibly imagine it as being concave).

The sight of that "nothing," completely lacking in contrast, on which the eye cannot find a supporting or resting point (as a result of which an awareness of the concept of "distance" also disappears), becomes in time unbearable and leads to insanity, since our willpower isn't strong enough to keep our eyes closed continuously.

Isn't it fascinating to realize that no image, no form, not even a shade or color, "exists" on its own; that among everything that's visually observable we can refer only to relationships and to contrasts? If one quantity cannot be compared with another, then no quantity exists. There is no "black" on its own, or "white" either. They only manifest themselves together and by means of each other. We only assign them a value by comparing them with each other.

One would be inclined to think that for a blind person the world is dark. But no, how would he know what "dark" means if he does not know light?

(Moreover, I would like to make a distinction between "light-and-dark" on the one hand and "white-and-black" on the other.

We can consider light and darkness as immaterial, although I doubt whether that is acceptable from the point of view of physics. However, white and black, with the infinite number of hues between them, are the shades with which the surface of matter reveals itself to us: white when the light that strikes it is reflected, black when it is absorbed. The sun is light, snow is white; the night is dark, soot is black. However, the concept "light," or in a more general sense "emanation of light," makes no sense if there isn't somewhere a lump of matter that acts as sender and at least one other that acts as receiver. That's why, according to Genesis, creation rightfully starts with the creation of heaven and earth: first, separation of emptiness and substance, and only subsequently creation of light. It is remarkable that the diffuse light mentioned in chapter 1, verse 3, only coalesces into emanating heavenly bodies in verse 14.)

Anyway, we were talking about the white paper and the black ink.

Isn't it really an utterly illogical way of acting to start from the one extreme at our disposal: the white paper? Wouldn't it be more valid, at least theoretically, to take the average between the two extremes as starting point: that is, paper in a shade of gray? After all, we aren't ink slingers by profession, are we?

If for a moment I may ignore the static result of a print, as it hangs on the wall fastened with four thumbtacks, and if I think only about the dynamic action, the time period between beginning and end of our "creation," then it seems absurd to me that starting with white paper we should cease our action before we have smeared the entire plane of our "composition" completely pitch black. Or better still the other way

around, as the wood-carver does (and possibly based on ethical-symbolic considerations), cutting away the black plane (the devil) until there is nothing left other than the white paper (God). However it's done, when starting from the one extreme, the road should logically be taken through to the other.

Such, however, are not our objectives (although artists such as Van der Leck and Mondriaan perhaps weren't too far from these in their thinking), and, if for practical reasons it wasn't usually preferable to use white paper, I myself would give preference to gray. Anyhow, it is sometimes also advisable for practical reasons to draw with white and black chalk on gray paper, for example, when sketching outdoors in the bright sun.

The graphic artist could partly compensate for what I consider the absurdity in his action by setting his prints in a gray border. By doing this, he would give a suggestion to the observer, "Remember, it is true that the paper on which I printed was white, but gray is still my starting point."

In fact, for a long time I formerly used gray borders, but I dropped what I consider a logical reasoning and capitulated to the present fashion of the white border, to my shame, I must confess.

A generally recognized and applied rule or custom does not need to be esthetically justified, but according to my point of view logic and esthetics cannot be in conflict with one another. Perhaps there is something lacking in my logical reasoning. If so, then I am anxious for someone to set me right.

July, 1951
M.C. Escher

# A GRAPHIC ARTIST WITH HEART AND SOUL

Acceptance speech by M.C. Escher upon receiving the Culture Prize of the City of Hilversum on March 5, 1965.

Hilversum, March 5, 1965

Mr. Mayor,
Ladies and gentlemen of the city administration,
Members of the jury,
Ladies and gentlemen,

It is a pleasure to express my gratitude to the mayor and aldermen of this community for the honor that is bestowed on me today. With sincere appreciation I receive from their hands the 1965 Hilversum Culture Prize.

I also owe thanks to the members of the jury who considered me worthy of being nominated for this distinction. Specifically I owe thanks to the president and the secretary of the jury, who made a real effort to recommend my work in such flattering terms.

I am also very pleased that some of my family members and many of my friends have considered it worth the effort to come here for the ceremony. Their presence is heartwarming.

I want to cordially thank you personally, Mr. Mayor, for the friendly and appreciative words that you have just addressed to me. I wish my reply to them could be as spontaneous and witty as those I recall of my colleagues, who in previous years received this distinction.

However, by nature I am simply not spontaneous. The execution of a graphic print requires patience and thoughtfulness. In addition, the ideas I want to express therein

usually crystallize only after careful pondering. In fact, I spend most of my time in a quiet studio and, as propitious as that may be for the exercise of my profession, it definitely does not advance eloquence.

I must make a confession to you. When the secretary of the jury came to tell me the happy news a few weeks ago, my first reaction wasn't one of happiness but rather of terror. My first thought was, "Oh, oh, now you will have to come out of your shell and spend an evening exhibiting polite and pleasant behavior.

But that initial feeling of diffidence about a public ceremony fortunately was soon dispelled by more pleasant sensations.

First of all, whether you want to or not, you feel flattered when something like this happens to you.

Secondly, I was pleasantly surprised by the announcement that I would not have to appear all by myself as the focus of the festivities, but that a young colleague had been chosen by the jury as my partner. By the way, my pleasure in this certainly isn't just because the presence of Marte Röling as a fellow honoree is a support for me. No, I am also very glad because I admire the work that testifies to her great talent. I ask you, who wouldn't be happy to be in such attractive and excellent company?

And then there is a third circumstance, which has swept away the last remnant of my faintheartedness. The honor fell to me to select the musical accompaniment for the evening. Now I didn't have a moment's trouble with that. I'll quickly tell you why.

It must have been in 1950 when, in the Small Hall of the Concertgebouw, I first heard Janny van Wering play Bach's Goldberg variations on the piano. That concert made an indelible impression on me. I sat listening in breathless ecstasy to that glorious music. And the farther along the stream of variations advanced, the greater my admiration became for her masterly interpretation. That was the Bach to whom I have pledged my heart and my intellect at the same time. Such beauty, of composition as well as of execution, cannot possibly be expressed in words.

Subsequently I again heard Mrs. van Wering play the Goldberg variations, and I have also gotten to know them better through recordings. All the pearls of that string are of a miraculous purity, but that doesn't mean you cannot prefer one pearl more than another. It is a matter of personal taste. For example, my special preference goes to the twenty-fifth in the series. Do you understand now how proud I am that she has consented to play that particular variation for me as a part of her program today?

Bach's music may perhaps provide the occasion to say a few words about my work. I had better not expound on the affinity I seem to have discovered between the canon in polyphonic music and the regular division of a plane into figures with identical forms, no matter how striking it is to me that the Baroque composers have performed manipulations with sounds similar to the ones I love to do with visual images.

Allow me to say only that Father Bach has been a strong inspiration to me, and that

many a print reached definite form in my mind while I was listening to the lucid, logical language he speaks, while I was drinking the clear wine he pours.

When one speaks about "lucid" and "logical," one thinks involuntarily of mathematics. In high school in Arnhem I was a particularly poor student in arithmetic and algebra because I had, and still have, great trouble with the abstractions of numbers and letters. Things went a little better in geometry when I was called upon to use my imagination, but I never excelled in this subject either while in school.

But our path through life can take strange turns.

When upon completion of high school I became a student at the Haarlem School for Architecture and Decorative Arts, I came within a hairsbreadth of having the opportunity to become a useful member of society. My parents registered me as a student in architecture. But the school also offered a course in graphic arts taught by S. Jessurun de Mesquita, and I have every reason in the world to remain grateful to him for the rest of my life, first as teacher and later as fatherly friend. He saw something in the small linoleum carvings I had made while still in high school, and he persuaded my parents to let me drop architecture in order to try and see if I had it in me to be a graphic artist. In the beginning my father didn't think it such a good idea, but I myself was only too pleased with that change of direction.

Although I am even now still a layman in the area of mathematics, and although I lack theoretical knowledge, the mathematicians, and in particular the crystallographers, have had considerable influence on my work of the last twenty years. The laws of the phenomena around us—order, regularity, cyclical repetitions, and renewals—have assumed greater and greater importance for me. The awareness of their presence gives me peace and provides me with support. I try in my prints to testify that we live in a beautiful and orderly world, and not in a formless chaos, as it sometimes seems.

My subjects are often also playful. I can't keep from fooling around with our irrefutable certainties. It is, for example, a pleasure knowingly to mix up two- and three-dimensionalities, flat and spatial, and to make fun of gravity.

Are you really sure that a floor can't also be a ceiling?

Are you definitely convinced that you will be on a higher plane when you walk up a staircase?

Is it a fact as far as you are concerned that half an egg isn't also half an empty shell?

Such apparently silly questions I pose first of all to myself (because I am my own first observer), and then to others who are kind enough to come and observe my work. It is satisfying to note that quite a few people enjoy this kind of playfulness, and that they aren't afraid to modify their thinking about rock-solid realities.

Above all I take pleasure in the contacts and friendships with mathematicians that I owe to this. They have often provided me with new ideas, and sometimes an interaction between them and myself even develops. How playful they can be, those learned ladies and gentlemen!

To tell you the truth, I find the concept "art" a bit of a dilemma. What one person calls "art" is often not "art" for another. "Beautiful" and "ugly" are old-fashioned concepts that are only rarely brought into the picture nowadays — maybe rightfully so, who is to say? Something repellent, something that gives you a moral hangover, something that hurts your eyes or ears can still be art!

Only when the sentiment is kitsch is it not art; we all agree on that. Certainly, but what is kitsch? If only I knew that! I find such determinations of value based on feelings too subjective and vague. If I'm not mistaken, the words "art" and "artist" did not yet exist during and before the Renaissance. Architects, sculptors, and painters at the time were simply considered practitioners of a craft.

The graphic arts are also an honest craft, and I consider it a privilege to be a member of the guild of graphic artists. Cutting with a gouge or engraving with a burin in a woodblock polished mirror smooth is not something on which you necessarily pride yourself; it is simply a pleasant type of work. The only thing is that as you get older it takes more time and effort and the chips fly somewhat less tempestuously about your workbench than they used to.

So I am a graphic artist with heart and soul, but the rating "artist" makes me feel a little embarrassed.

That is why, Mr. Mayor (and I would like to end on this note), I prefer to receive my honor as a graphic artist pure and simple, if I may express it this way. I hope that you consent to my accepting it as such.

# 2

## THE LECTURES THAT WERE NEVER GIVEN

In October, 1964, Escher and his wife went to Canada to visit their eldest son, George, and his family. Since the beginning of that year, Escher had conducted an extensive correspondence with various people and organizations in the United States who had previously indicated their hope that he might make one or more presentations if the opportunity arose. Escher's visit to Canada would now raise the possibility of an American speaking tour.

In the course of 1964 an ambitious program was put together for the presentation of lectures:

| | |
|---|---|
| Friday, October 9 | Bennington College, Bennington, Vermont, lecture 3. |
| Wednesday, October 14 | Ledgemont Laboratory, Lexington, Massachusetts (Kennecott Copper Corporation), lecture 1. |
| Thursday, October 15 | Ledgemont Laboratory, lecture 2. |
| Friday, October 16 | Netherlands Academic Circle, Lexington, lecture 3. |
| Sunday, October 18 | M.I.T. Course XXI Society, Cambridge, Massachusetts, lecture 3. |
| Tuesday, October 20 | Pratt Institute, New York, lecture 3. |
| Wednesday, October 21 | Netherlands Circle, New York, lecture 3 (in Dutch). |
| Thursday, October 22 | Bell Laboratories, Murray Hill, New Jersey, lecture 3. |

Shortly after arriving in Canada, however, Escher had to be admitted to Saint Michael's Hospital in Toronto for an emergency operation. All appointments had to be canceled, and Escher would never again have a chance to give his carefully prepared lectures. His health no longer permitted it.

Escher had written the complete English text of his lectures (a detailed overview of his work in two lectures and a more succinct overview in one lecture, thus a total of three). Fortunately these texts have been preserved, because what Escher had to say about his work is extremely worthwhile and therefore reason to include in this book the two lectures in the "detailed version," accompanied by all the slides Escher had wanted to show. In order not to diminish the tone of the lectures, we have left Escher's text completely intact, including statements regarding ceremony, intermissions, and similar remarks.

# THE REGULAR DIVISION OF THE PLANE

Mr. Chairman, ladies and gentlemen,

It is an honor and a pleasure for me to show you a series of slides illustrating my work.

You may expect a graphic artist who shows his prints to speak about his techniques, which are in my case the woodcut, the lithograph, and the copper engraving, but as I need all the available time to talk about my *intentions*, about the question *why* I made these prints, I must leave the question of *how* they were made unanswered.

I propose to dedicate this first talk exclusively to my *investigations and my applications of the rules of symmetry to the plane.*

Many of the bright-colored, tile-covered walls and floors of the palaces of the Alhambra in Spain show us that the Moors were masters in the art of filling a plane with similar, interlocking figures, bordering on one another without gaps. Japanese artists also produced some excellent examples of these curious patterns.

What a pity that the religion of the Moors forbade them to make images! It seems to me that they sometimes came very close to the development of their elements into more significant figures than the abstract geometric shapes that they created. No Moorish artist has, as far as I know, ever dared (or didn't he hit on the idea?) to use as building components concrete, recognizable figures borrowed from nature, such as fishes, birds, reptiles, or human beings. This is hardly believable, for *recognizability* is so important to *me* that I never could do without it.

Another important question is *color contrast.* It has always been self-evident for the Moors to compose their tile-scenes with pieces of majolica in contrasting colors. Likewise I have never hesitated myself to use color contrast as a means of visually separating my adjacent pattern components.

Let me try to justify these ideas with the aid of my slides.

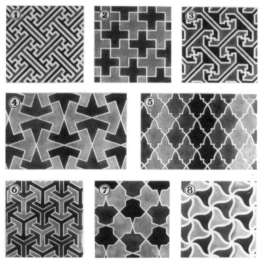

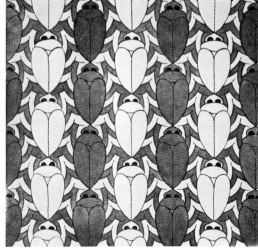

*Eight Copies of Space-filling Designs*              *Symmetry Work 91*

The left slide shows eight examples of geometric-artistic applications. Number 1 is a very well known Japanese pattern. It has some resemblance to number 3, which is a Moorish wall decoration that I copied in the Mesquita-Cathedral of Córdoba in Spain. (Both are composed of similar H-shaped figures.) Number 2 is Russian or Greek; I saw it frequently as a motif of clerical garb on icons. The numbers 4, 5, 6, 7, and 8 are all Moorish, copied in the Alhambra. Striking in all these patterns is the absence of asymmetric figures, as well as of glide reflections.

To the right: a first example of my own invention: a bilaterally symmetric beetle, repeated on the plane in the same way as number 5, left.

I would now like to show some examples of my applications of the three main principles of regular plane filling: first some cases of *translation*, secondly of *axes*, and thirdly of *glide reflections*.

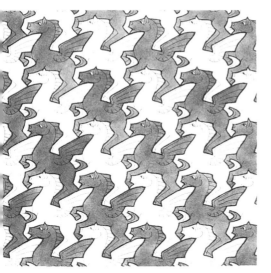 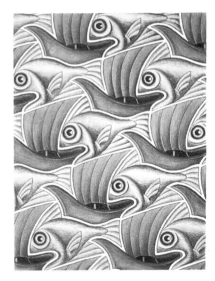

*Symmetry Work 105*          *Symmetry Work 72*

Two examples of *translation:* on the left a prancing horse, on the right a combination of two different figures: a boat and a fish.

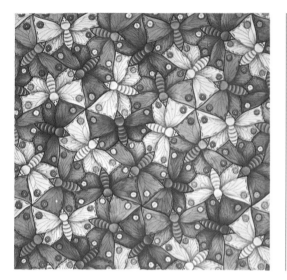

*Symmetry Work 70*

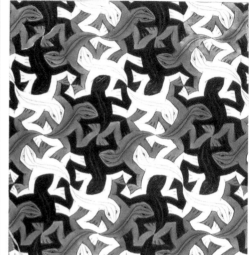

*Symmetry Work 56*

Two examples of *axes:* the figures of both slides repeat themselves by turning around *binary, ternary,* and *senary* axes.

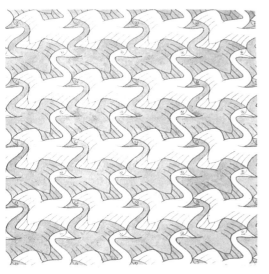

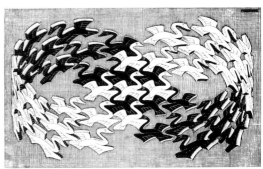

*Symmetry Work 96*

*Swans*

Here is an example of *glide reflection*. The swans on the left appear again in the woodcut on the right. My purpose in making this print was to give a demonstration of that same glide-reflection principle. Aiming to prove that the white swans are mirror reflections of the black ones, I let them fly around, in a path having the form of a recumbent 8. Each bird rises from plane to space, like a flat biscuit sprinkled with sugar on one side and with chocolate on the other. In the center of the 8, the white and the black streams of swans intersect and form together a pattern without gaps.

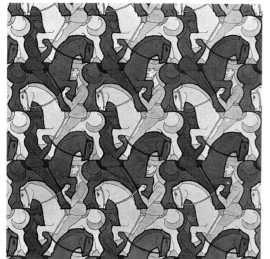

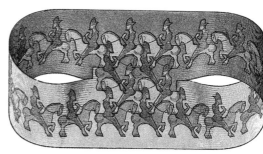

*Symmetry Work 67*

*Horsemen*

Here is a second example of *glide reflection*. The left horseman, as a creature, was exceptionally obliging and willing. It happens rarely that my subjects so meekly allow themselves to be portrayed in detail.

To the right the glide-reflection principle is demonstrated once again. A ribbon is suggested, on which a procession of horsemen rides on endlessly. It's like a woven fabric, with warp and woof of different colors. Thus blue figures on a red background on one side of the ribbon reappear as red on a blue background on the opposite side. In the center, blue and red riders grow together and completely fill up the plane.

I often have wondered at this, for an artist, unusual mania of mine to design periodic drawings. Over the years I made about a hundred fifty of them. In the beginning, that was some forty years ago, I puzzled quite instinctively, apparently without any well-defined purpose. I was simply driven by the irresistible pleasure I felt in repeating the same figures on a piece of paper. I had not yet seen the tile decorations of the Alhambra and never heard of crystallography; so I did not even know that my game was based on rules that have been scientifically investigated.

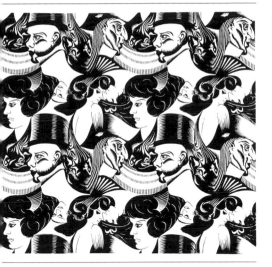

*Eight Heads*           *Eight Heads, Rotated 180°*

Here I show you my first periodic woodcut, made in 1922. The original woodblock presents a collection of eight different human heads, which can be printed and multiplied by translation.

On the left slide four of them are visible: two gentlemen and two ladies. If you turn the whole thing 180 degrees, four other heads appear, once more two women and two men. Some parts have double functions: a plume on a three-cornered hat = an upper arm; two men share their hair.

Many years later, in 1935, I came for the first time in contact with crystallographers, and I tried seriously to understand their theories. But their writings are mostly too scientific for me, and on the other hand they took no account of the, to me, indispensable color contrasts. So in 1942 I came to formulate a personal layman's theory, which I illustrated with many explanatory figures. Though the *text* of crystallographic publications is mostly beyond my comprehension, the *figures* with which they are often illustrated bring me occasionally on the track of new possibilities for my work. In this way a fruitful contact could sometimes be established between mathematicians and myself.

Mosaic I                                    Mosaic II

I should like to round off this introduction to my periodic patterns with these two tessellations, which contain no repeating figures whatever. So they really do not belong to the subject of this talk, but I show them all the same because they clearly illustrate my two main requisites: recognizability and color contrast. If one couldn't recognize them as living beings or as a well-known object (the guitar, for instance), it would have been a senseless game to put them together; and without a shade contrast between two adjacent figures they would simply be invisible!

Composing such a jigsaw puzzle is done more or less unconsciously. While drawing, I feel as if I were a spiritualistic medium, controlled by the creatures that I am conjuring up, and it is as if they themselves decide on the shape in which they like to appear.

A contour line between two interlocking figures has a double function, and the act of tracing such a line therefore presents a special difficulty. On either side of it, a figure takes shape simultaneously. But, as the human mind can't be busy with two things at the same moment, there must be a quick and continuous jumping from one side to the other. The desire to overcome this fascinating difficulty is perhaps the very reason for my continuing activity in this field.

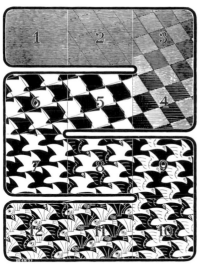

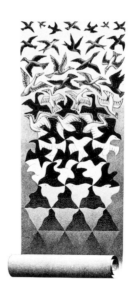

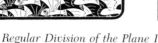
*Regular Division of the Plane I*

*Liberation*

After this introduction I now propose to show and to discuss several series of prints that are the results of particular trains of thought to which my symmetry figures can lead.

First, some examples illustrating *developments of shape and contrast.*

The left print presents a gradual development in twelve stages. An image composed of black-and-white spots is generally looked at as a static thing, and we don't ask how it came into being. But if we consider it as the result of a dynamic action, we logically should start with a uniform gray plane: 1. Two systems of intersecting straight lines divide this plane into similar parallelograms: 2, and by and by their mutual color contrast grows toward pure black and white shapes: 4. This is the starting point of their form evolution, which attains its maximum form at the end of 7. Black figures become recognizable as birds on a white background: 8, or, if you like, as white birds on a black background: 9, or, simultaneously, as black and white birds: 10. But the same shapes can also suggest flying fishes instead of birds by moving their beak and eye from right to left: 11. Finally it's obvious that a combination of birds and fishes is also possible: 12.

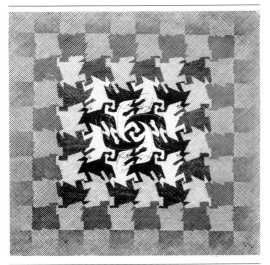

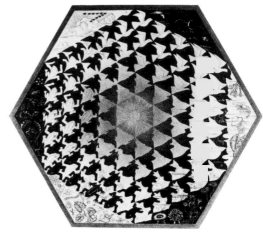

*Development I*

*Verbum*

Two more examples of evolution. In the left print this process takes place from the outside toward the center. The borders of the square suggest a misty gray initial stage, while in the center four figures attain their ultimate and maximal developed form, as well as their strongest contrast.

To the right: an evolution in the opposite direction—from the center toward the outside—is much better because, instead of four locked-in, central shapes, a long row of end figures can be presented at the borders. In the center the word VERBUM ("In principium erat Verbum") recalls the biblical story of creation. Emerging from a nebulous, misty center, primordial triangles evolve gradually into birds, fishes, and frogs, each in their own element: sky, water, and earth. Each species presents itself in two forms: in daytime and at night. One by one they merge into each other, along the borders of the hexagon, in a clockwise direction.

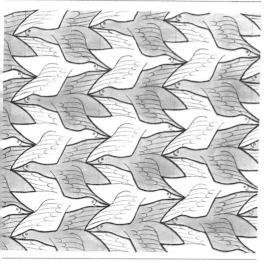

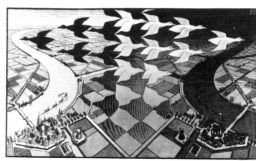

*Symmetry Work 18*

*Day and Night*

Now two examples to illustrate another subject, which I call *function and meaning of backgrounds.*

To the left: a pattern that is the basic theme of the print on the right: *Day and Night.*

It's a remarkable characteristic of the recognizable figures of a periodic drawing (which are birds in this case) that our eyes never see a continuous pattern but fix their attention either on the dark blue birds or on the white ones; the blue and the white birds can never be seen simultaneously as objects, but function alternatively as one another's background.

The idea to make a print on the subject "Day and Night," as shown to the right, was logically born from the associations: light = day, and dark = night.

Rectangular fields between two little, typically Dutch towns evolve gradually upward into the silhouettes of birds flying in opposite directions: black to the left and white to the right, both emerging from the center. At the left, the white silhouettes merge and form a day sky; to the right, the black ones melt together and form a nocturnal background. The two landscapes are each other's mirror image and flow together through the fields, from which, once again, the birds take shape.

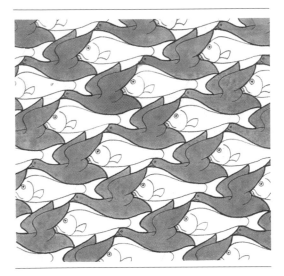

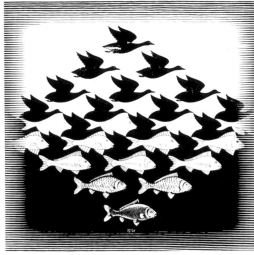

*Symmetry Work 22*                    *Sky and Water I*

In the same way that we associate "flying birds" with "sky," so we connect "water" with "fishes." A plane pattern composed of birds and fishes, as you see to the left, thus led me to the idea of the right image. The square is divided exactly into halves by a horizontal central strip in which the white and the black components are equivalent. Above, the white fish silhouettes merge to form the "sky" for the birds, while in the lower half the black birds blend together to form "water" for the fishes.

Let me now show you two attempts to symbolize the idea of boundlessness.

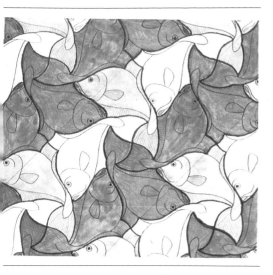

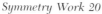

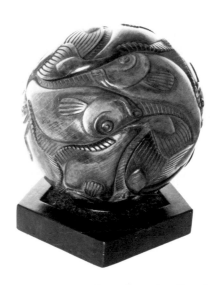

*Symmetry Work 20*                    *Carved Beechwood Ball with Fish*

To the left is shown, once again, a fragment of a plane, which could be filled endlessly with similar fish figures. The simplest way to eliminate the fragmentary aspect of such an image is to take a sphere instead of a flat piece of paper and to divide its curved surface into a limited number of these figures.

To the right, a beechwood ball is shown, about six inches in diameter, on which I carved twelve identical fishes in low relief, filling up the entire sphere surface. When you turn this ball in your hands, fish after fish appears in endless succession. Though their number is restricted, they symbolize the idea of boundlessness in a manner that is not obtainable on a plane.

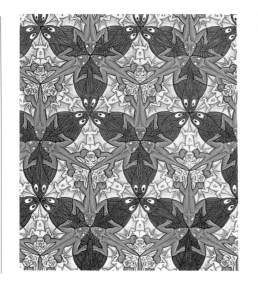

*Symmetry Work 85*

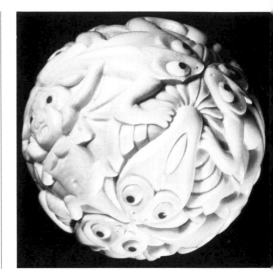

*Three Elements*

Frogs, fishes, and bats can also fill up a plane, as well as a sphere surface, as you see on these two slides. Ternary axes on the plane are substituted for binary axes on the sphere.

I am particularly fond of this little ivory ball, which measures about three inches in diameter. Though the design is mine, the carving was done by a Japanese netsuke carver by order of one of my best American customers. Three geodesics, crossing one another perpendicularly, mark the symmetry axes of every species of animal, symbolizing *earth* (the creeping frogs), *sky* (the flying bats), and *water* (the swimming fishes).

[Interval]

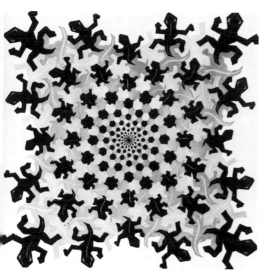

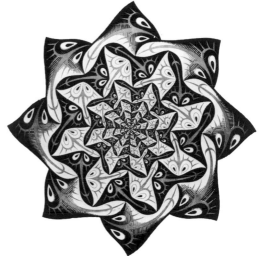

*Development II*                                     *Path of Life I*

Up to now we have made no attempt to change the *size* of tessellation elements. But it's logical that, by gradually reducing each figure, a limit of the infinitely small can theoretically be reached, symbolizing an *infinity of number, or a totality.* This idea has long fascinated me, and a series of prints was the result.

The left slide shows a metamorphosis of hexagons into reptiles, from the center (where the elements are infinitely small) toward the borders. The result, however, is not altogether satisfactory because the plane is arbitrarily bounded: it could be extended by choice and thus does not present a totality.

In the right print I have tried to remedy this evil. With your eyes you are invited to follow currents of white ray fishes spiring head to tail from the center outward. The eight biggest rays spire inward again, toward the middle, changing their color from white to black.

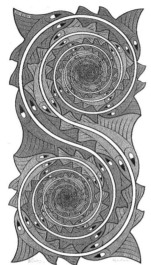

*Whirlpools*

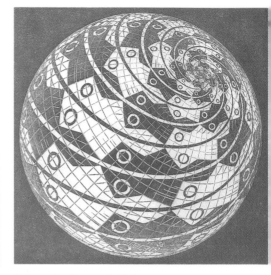

*Sphere Surface with Fish*

The left print presents two nuclei with infinitely small figures. They are linked by a red and a blue row of fishes swimming head to tail and moving in opposite directions. The whole red trail has exactly the same shape as the blue one. When rotated 180 degrees around an axis in the center, they cover each other's open interspaces. Since I employed the woodcut technique to make this print, I needed only a single block, with which both colors were printed.

The right print suggests a sphere with two poles, of which only one is visible. They are connected by four white and four black trails of fishes swimming head to tail and spiring, all in the same direction, from pole to pole.

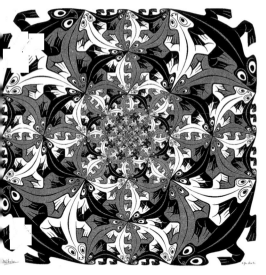

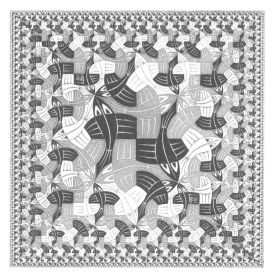

*Smaller and Smaller*                    *Square Limit*

To the left is another example of inward size reduction. The components continuously halve themselves. In this woodcut I have consistently and almost maniacally continued the reduction down to the limit of practical execution. I was dependent on four factors: the quality of my wood material, the sharpness of my tool, the steadiness of my hand, and especially my keen-sightedness, aided by a twelve-times-enlarging magnifying glass.

However, this centripetal reduction is once again unsatisfactory because of the arbitrary outward limitation. The best way to obtain a gratifying, logically bounded totality is a reduction of the figures in the *opposite* direction: from the center toward the borders, as shown to the right, where a square limit encloses an infinite number of fishes, which also continuously halve themselves.

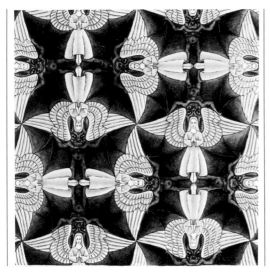

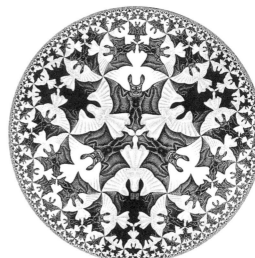

*Symmetry Work 45*                    *Circle Limit IV*

Instead of finishing with a square limit, one can also, and perhaps better, end with a circular outline. But this is no simple question, but a complicated, non-Euclidean problem, much too difficult for a layman, as I am. After a long time of trying, in vain, in my own experimental way, I was finally put on the right path by a publication of the English mathematician Professor H.S.M. Coxeter. Without his kind assistance I probably would never have found a satisfactory solution.

To the left: angels and devils, built up with *quaternary* and *binary* axes. To the right: the same figures reducing in a centrifugal direction by alternating *quaternary* and *ternary* axes.

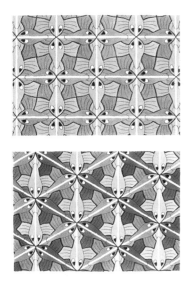

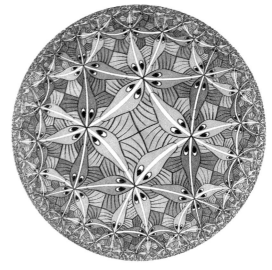

Symmetry Works 122 and 123          Circle Limit III

Here you see three modes of filling a plane with bilaterally symmetrical fish figures. White lines mark their symmetry axes.

The upper-left drawing, with its rectangular intersecting white lines, is the least interesting of the three. The fishes, which are presented tail to tail and head to head, do not suggest any continuity. It shows a combination of *quaternary* and *binary* axes and needs a minimum of *two contrasting colors* (yellow and blue).

The lower-left drawing suits me a bit better. The rows of fishes, intersecting at angles of sixty degrees, swim head to tail and suggest a unidirectional continuity. All trails with the same direction also have the same color. There are *two ternary axes*, and a minimum of *three colors* is needed (yellow, blue, and red).

To the right is another circle-limited print. Uninterrupted trails of unidirectional fishes grow in size as long as they approach the center and shrink again toward the border. There are alternating *quaternary* and *ternary* axes, and a minimum of *four colors* is needed (yellow, blue, red, and green).

It is perhaps worthwhile to call attention to the elaborate woodcut technique of this print; it required five different woodblocks: one for the black lines and four for the colors. Every block covering a sector of ninety degrees of the whole circle, the complete disk needed four times five, that is, twenty printings.

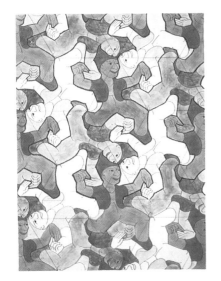

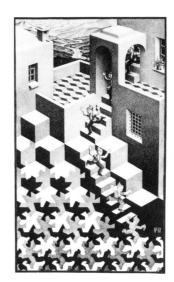

*Symmetry Work 21*                                        *Cycle*

Let me now give you some specimens of *"image stories,"* suggesting *transitions from the plane to the space.*

On the left slide, little men in three colors fill the plane. That same motif is the main theme of the right print. The little man leaves his house and runs down a staircase. On his way down he loses his three-dimensionality and arrives, flat and gray, amid white and black fellow creatures. Each of them is simplified into a rhomb. Three rhombs suggest a cube; the cube borders the house, and from the house the little man again appears. And so on and so on, in an endless annular movement.

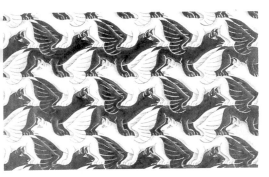

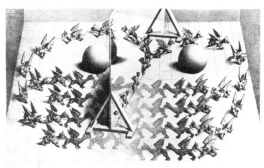

*Symmetry Work 66*

*Magic Mirror*

To the left: yellow and black trails of winged lions are each other's glide reflections.

To the right: the same little animal is born in and emerges from a vertical looking glass. More and more comes out of the mirror until at last the whole creature has freed itself from its image. As a fabulous animal, it transposes its reflection into reality—a well-known trick since Alice and her Looking-glass world. Thus two curved processions move on, first in one row, then in two rows, and finally in four rows, moving from left to right and from right to left. They meet in the foreground, lose their three-dimensionality, become flat, and slide together as pieces of a jigsaw puzzle. Together they now form a horizontal plane, a tiled floor, on which stands the looking glass.

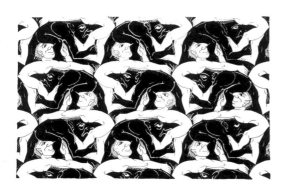

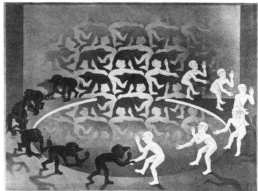

*Symmetry Work 63*

*Encounter*

Left: a pattern of white optimists and black pessimists, worked out, on the right print, to a complete moralizing story. In the background, on a gray wall, these human figures increase their mutual contrast toward the center. One white and one black representative of each kind detach themselves from the wall surface and walk into space, carefully avoiding a tumble into the circular hole in the floor. Thus going round, they can't help meeting in the foreground. During the whole way, up to the end, the black pessimist keeps his finger raised in a gesture of warning, but the white optimist cheerfully comes to his encounter, and so they finally shake hands.

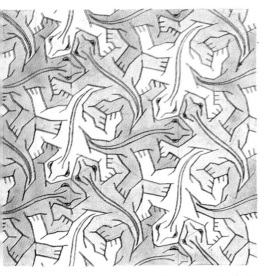

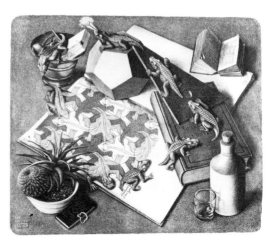

*Symmetry Work 25*

*Reptiles*

The left periodic drawing of reptiles in three colors is shown again in the right print as the page of an open sketchbook. One animal, apparently wanting to demonstrate that he is a living creature, lifts a claw across the edge of the book, pulls himself free still further, and begins his life cycle. First he clambers up onto a book, then climbs over the slippery surface of a set square, and reaches his summit on the top of a dodecahedron. A moment's pause, to puff and blow, tired but content, and then he resumes his way downward to the level plane, to the flatland, in which he reassumes his function of symmetry figure.

I never had any moralizing or symbolizing intention with this print, but some years later one of my learned customers told me that it is a striking illustration of the doctrine of reincarnation. So it appears that one can even be symbolizing without knowing it.

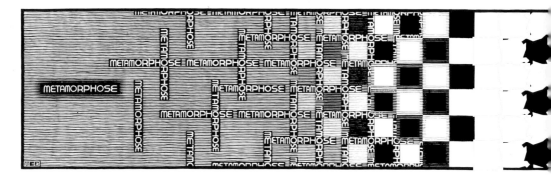

*Metamorphose II*
    *(1)*

I propose to round off this talk by showing you a woodcut strip with a length of thirteen feet. It's much too long to display in one or even in two slides, so I had it photographed in six parts, which I can present in three successive pairs and which you are invited to look at as if it were one uninterrupted piece of paper.

It's a picture story consisting of many successive stages of transformation. The word "Metamorphose" itself serves as a point of departure. Placed horizontally and vertically in the plane, with the letters O and M as points of intersection, the words are gradually transformed into a mosaic of black and white squares, which, in turn, develop into reptiles. If a comparison with music is allowed, one might say that, up to this point, the melody was written in two-quarter measure.

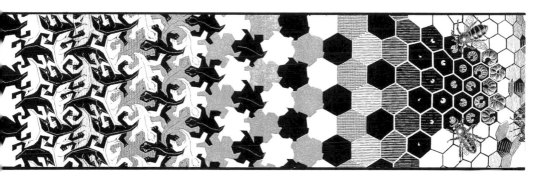

*Metamorphose II*
*(2)*

Now the rhythm changes: bluish elements are added to the white and black, and it turns into a three-quarter measure. By and by each figure simplifies into a regular hexagon. At this point an association of ideas occurs: hexagons are reminiscent of the cells of a honeycomb, and no sooner has this thought occurred than a bee larva begins to stir in every cell. In a flash every adult larva has developed into a mature bee, and soon these insects fly out into space.

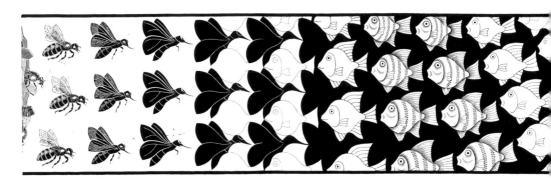

*Metamorphose II*
   *(3)*

The life span of my bees is short, for their black silhouettes soon merge to serve another function, namely, to provide a background for white fishes. These also, in turn, merge into each other, and the interspacings take on the shape of black birds. Then, in the distance, against a white background, appear little red-bird silhouettes. Constantly gaining in size, their contours soon touch those of their black fellow birds. What then remains of the white also takes a bird shape, so that three bird motifs, each with its own specific form and color, now entirely fill the surface in a rhythmic pattern.

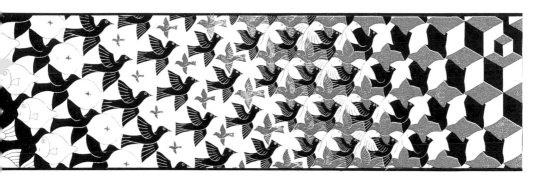

*Metamorphose II*
*(4)*

Again simplification follows: each bird is transformed into a rhomb, and this gives rise to a second association of ideas: a hexagon made up of three rhombs gives a plastic effect, appearing perspectively as a cube.

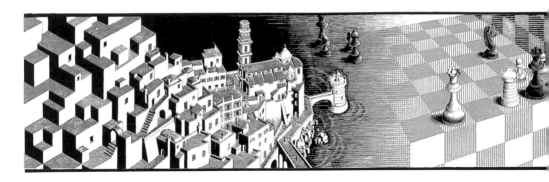

*Metamorphose II*
(5)

From cube to house is but one step, and from the houses a town is built up. It's a typical little town of southern Italy on the Mediterranean, with, as commonly seen on the Amalfi coast, a Saracen tower standing in the water and linked to shore by a bridge.

Now emerges the third association of ideas: town and sea are left behind, and interest is now centered on the tower: the rook and the other pieces on a chessboard.

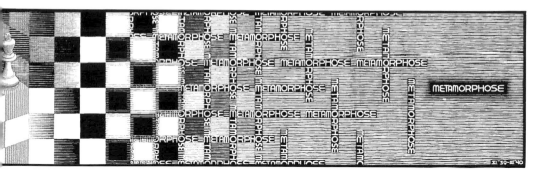

*Metamorphose II*
*(6)*

Meanwhile, the strip of paper on which "Metamorphose" is portrayed has grown to some twelve feet in length. It's time to finish the story, and this opportunity is offered by the chessboard, by the white and black squares, which at the start emerged from the letters and which now return to that same word, "Metamorphose."

Herewith I have come to the end of this talk, which I hope to continue tomorrow with quite different subjects. Thank you very much for your kind attention.

# OTHER THEMES

Mr. Chairman, ladies and gentlemen,

After my talk yesterday about the regular division of planes, I now propose to show a second series of fifty slides illustrating various other themes.

By way of introduction, I start with two examples of a faithful observation of reality. I made them both during the many years that I lived in Italy. The outer appearances of landscape and architecture are so engaging, especially in southern Italy, that I felt no need to express more personal ideas.

The mountain landscape at left was made in 1930 in Abruzzi. I remember exactly sitting at the border of that narrow country road with no other want than to depict, as faithfully as possible, the wide and gripping prospect before me.

To the right: a wood engraving of 1935, an interior of Saint Peter's Church in Rome. I made the drawing for this print sitting in the upper gallery of the dome, looking down with a giddy feeling into the abyss before me. This was perhaps the first time I realized that all the vertical lines were directed toward the same point in the nadir. So this print may be the primary cause of the series of perspective fantasies I developed many years later.

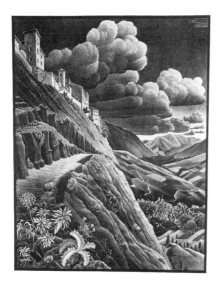

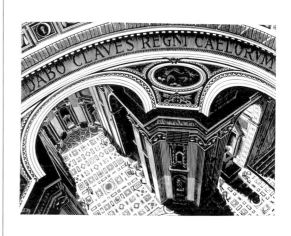

*Castrovalva*

*Inside St. Peter's*

Two more early prints of 1930 and 1935. Both are fantasies, but built up with various elements that I depicted from nature.

The left one is again typically Abruzzian. You can still see there (or at least you could in 1930) some specimen of very old, narrow, and perilous "devil bridges."

The right print combines three distinct elements: first the architecture, a reminiscence of a curious little twelfth-century church in southern Italy. It consisted of loose cross vaults under an overhanging rock. Secondly the marble sarcophagus with the recumbent figure of a bishop, which I saw in the crypt of Saint Peter's in Rome. And thirdly an insect common in southern Italy, a praying mantis. It sat down on the edge of my drawing folder, while I was sketching somewhere in Sicily, long enough to be pictured in detail.

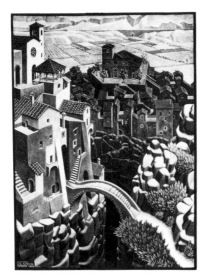

*The Bridge*

*Dream*

Though it was some twenty years later that I made these two prints, they express a similar space suggestion. Both are perspective constructions without elements copied from nature. My only intention was to suggest an impression of three-dimensionality, of endless depth.

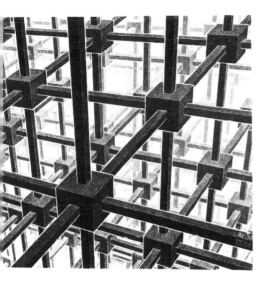

*Cubic Space Filling*

*Depth*

The left consists of three systems of parallel beams intersecting at right angles and dividing each other into pieces of equal length. Each is the edge of a cube, and thus space is filled with an infinite number of cubes of equal volume.

Each fish in the right print is located at the nodal point on three axes, intersecting at right angles.

Both prints present characteristic holes and empty tracks. It is a curious sensation to assist at their slow and automatic appearance during the long work of perspective drawing.

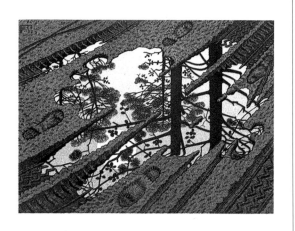

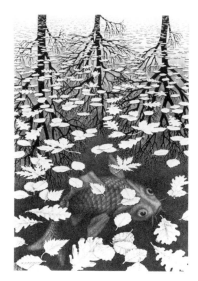

*Puddle*

*Three Worlds*

Let us now change the subject and look at several examples of reflection. First three water reflections.

The left print shows a puddle, left behind after a shower, in a rutted hollow of a woodland road. It reflects a calm, cloudless evening sky. Traces of two trucks, two bicycles, and two pedestrians are imprinted in the soggy ground. One of the walkers went from left to right, the other from right to left.

The other print, of a forest pond, has three distinct components. First the fallen autumn leaves, receding toward an invisible horizon, suggest the surface of the water. Secondly the reflections of three trees in the distance, and thirdly there is the fish in the foreground below the water surface.

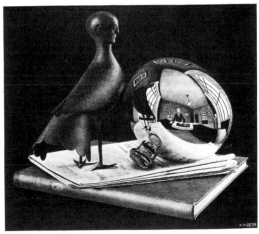

*Rippled Surface*

*Still Life with Reflecting Sphere*

To the left a third water reflection. Two systems of concentrically expanding ripples are generated by ascending air bubbles or by falling raindrops. They disturb the stillness of the reflection of a tree with the moon behind it. The circles, perspectively seen as ellipses, are the only means to suggest the water surface.

Now, from horizontal mirrors over to curved looking glasses. To the right a still life with, as the main object, a bulb-shaped mirror bottle. In former days they used to be placed on a stick in the middle of old-fashioned gardens. The other object, to the left of the bottle, is no fantasia of mine but a Persian iron man-bird, which I have at home. It is mirrored in the bottle, as well as I am myself, sitting in my room in the act of drawing on a lithographic stone.

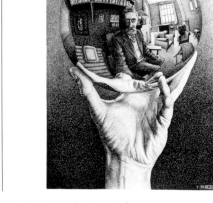

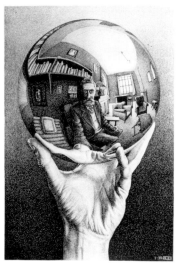

*Hand with Reflecting Sphere*

*Three Spheres II*

The left picture shows the same spherical mirror, resting on a *left* hand. But as a print is the reverse of the original stone drawing, it is my *right* hand that you see depicted. (Being left-handed, I needed my left hand to make the drawing.) Such a globe reflection collects almost one's whole surroundings in *one* disk-shaped image. The whole room, four walls, the floor, and the ceiling, everything, albeit distorted, is compressed into that one small circle. Your own head, or more exactly the point between your eyes, is in the center. No matter how you turn or twist yourself, you can't get out of that central point. You are immovably the focus of your world.

In the right print three balls are placed side by side: a translucent one, a reflecting one, and an ordinary one. The mirroring globe in the middle connects all three, for it reflects the two others as well as myself, sketching the three balls before me.

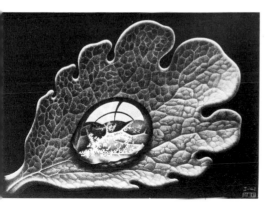

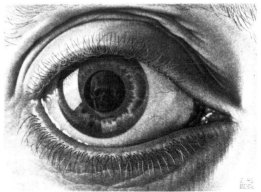

*Dewdrop*

*Eye*

To the left you see the enlargement of a leaf of a succulent plant; its actual size was about one inch. A dewdrop lies on it, reflecting a window. The tiny drop of water acts not only as a mirror but also as a lens, for through it one sees the magnified structure of the leaf's veins, with bright, shimmering air particles trapped between leaf and dewdrop.

On the right a last example of globular reflection: an eye, which is of course my own, copied as faithfully as possible in a concave shaving glass. It was necessary and logical to portray somebody in the pupil, an observer, reflected in the convex mirror of the eye. I chose the features of Good Man Bones, with whom we are all confronted, whether we like it or not.

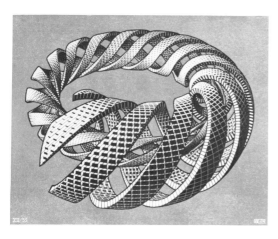

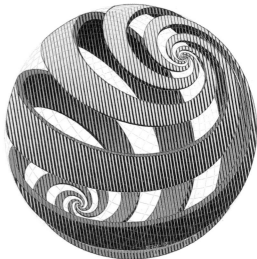

*Spirals*

*Sphere Spirals*

Let us change the subject once more and see some prints with *ribbons*. Curved ribbons or strips are suited to suggest a three-dimensionality, for instance, as shown to the left. Four spiraling strips form together a constantly narrowing ring and finally pierce into themselves.

On the right: a system of four theoretically never-ending ribbons, running over the surface of a sphere, link up its two poles. Both poles are visible, one externally and the other internally, through the open interspace between two ribbons.

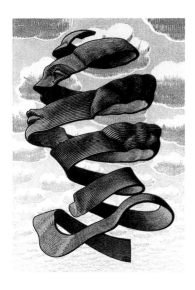

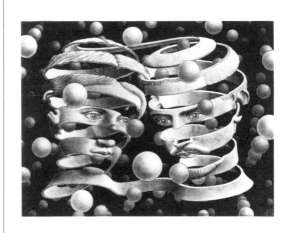

*Rind*                                                      *Bond of Union*

Two more spiral images. To the left: a spiraling ribbon, like an orange peel, portrays a fragmentary head of a woman. It floats through space as a hollow sculpture. The illusion of depth is accentuated by means of a cloud cover receding toward an invisible horizon.

A novel of H. G. Wells, entitled *The Invisible Man*, induced me to make this print. The hero of this fantastic story has prepared a mysterious chemical liquid. When he drinks it, his body becomes perfectly translucent. But this invisibility being rather inconvenient, he wants to get visible again and swathes his face with a bandage. My picture presents a similar situation. At the same time it gave me occasion to draw a recognizable portrait, externally as well as internally.

However, such an abruptly ending strip was not altogether satisfying, and therefore I made another print, which you see to the right. Here two spirals, portraying a woman's and a man's head, are united in one endless strip. With their foreheads even hooked to each other, they form together an indissoluble bond of union. Spheres, floating in front, between, and behind the folds of the empty heads, should suggest infinite space and time.

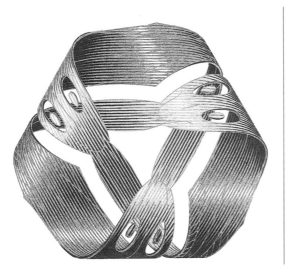

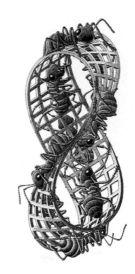

*Möbius Strip I*　　　　　　　　　　　*Möbius Strip II*

To conclude this ribbon series, I show you two Möbius strips. The left one is folded three times and is presented as if it were cut in two parts with a pair of scissors over the whole length. Nevertheless, it is still one uninterrupted slip, consisting of three fishes biting one another's tail.

The right slide shows a ribbon that is twisted only once. Nine red ants are walking in a continuous file, one after another, at both sides of the ribbon.

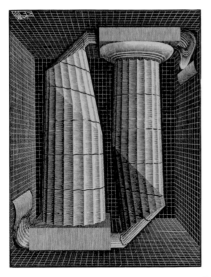

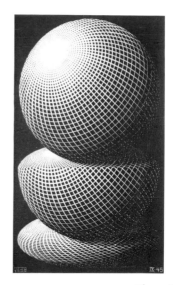

*Doric Columns*                                    *Three Spheres I*

I am now coming to a new subject — a group of six prints, which are difficult to explain in words because they express a typical image idea. One could call it *the conflict between two and three dimensions*.

The left slide presents two Doric columns side by side. The lower part of the left one gives the illusion of a solid, heavy, three-dimensional stone block. But it *is* a flat print, a two-dimensional projection. The complete column, apart from its surroundings, therefore can also be considered as a slip of paper, which one can fold and refold again till only a floppy sheet remains. I know it's an absurdity, but I can't help trying to depict it. The same contradiction happens with the right column: its upper part *seems* three-dimensional, but actually it *is* a flat strip. Folded and refolded, it ends in the lower-left corner as if squeezed by the weight of the left column.

A similar problem appears in the right print. At the top the plasticity of a sphere is suggested by a bright illumination on one side and a dark shadow on the other. But it isn't a sphere! It is only a flat circular image that one could cut out with a pair of scissors. Such a paper disk is shown in the center, folded in such a way that the lower half stands vertically and the top half horizontally; the top sphere rests upon that horizontal portion. But the disk can also be depicted like a round tabletop, at the bottom of the print. The two other disks (or spheres, if you prefer) rest upon it.

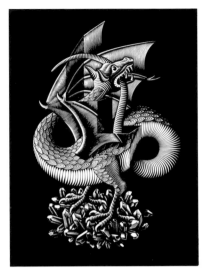

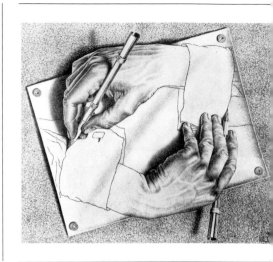

*Dragon*

*Drawing Hands*

To the left, another ambiguity: a more or less absurd dragon. It *pretends* to be spatial, but it *is* flat, and you can cut two incisions in it and fold it to obtain two holes. But pretending that it is three-dimensional at the same time, it slips its head through one opening and its tail through the other.

At the right, a sheet of paper is pinned upon a background with four thumbtacks. A right hand, holding a pencil, sketches a shirt cuff on it. It is only a rough sketch, but a little farther to the right a detailed drawing of a left hand emerges from the sleeve, rises from the plane, and comes to life. At its turn this left hand is sketching the cuff from which the right hand emerges.

Some years after I made this print I saw exactly the same idea of two hands drawing each other in a book by the famous American cartoonist Saul Steinberg.

*Opposite:*

The left print gives the illusion of a town, a block of houses with the sun shining on them. But again it's a fiction, for my paper remains flat. In a spirit of deriding my vain efforts and trying to break up the paper's flatness, I pretend to give it a blow with my fist at the back, but once again it's no good: the paper remains flat and I have created only the illusion of an illusion.

However, the consequence of my blow is that the balcony in the middle is about four times enlarged in comparison with the border objects. Some years later this central

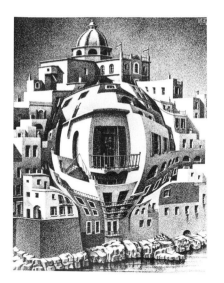

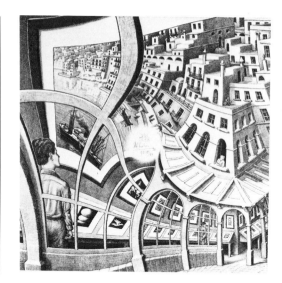

*Balcony*                                                                                    *Print Gallery*

expansion gave me the idea to make a new print, which you see to the right, with a ring-shaped expansion along the borders, in a clockwise direction, around an empty center. Let me try to follow this action, starting at the lower right corner.

Through a doorway we enter a picture gallery, where rows of prints are exhibited on the walls and tables. We first meet a visitor with his hands on his back and then a young man who is about four times taller. His head is still bigger in comparison with his hand because of the continuous circular expansion. He looks at the last of a row of prints hanging on the wall. He sees the ship, the sea, and the houses of a town in the background, all depicted on the print before him and all expanding continually. In one of the houses a woman is looking out of an open window. She also is a detail of the print that the young man contemplates, just like the sloping roof below her, under which the gallery is housed. Thus having let our eyes rove in a circular tour around the blank center, we come to the logical conclusion that the young man himself also must be part of the print he is looking at. He actually sees himself as a detail of the picture; reality and image are one and the same.

Perhaps we could pause now some minutes before I resume this talk.

[Interval]

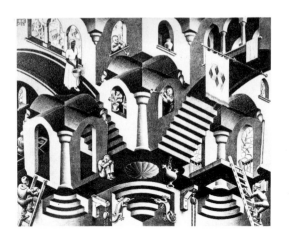

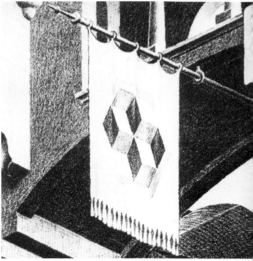

*Convex and Concave*                              *Detail from Convex and Concave*

Let us now drop the embarrassing relation between flat and spatial and look at an example of *inversion of concave into convex.* An enlarged detail of the left print is shown to the right: a banner, hanging underneath a bridge, presents a pattern of diamonds in three shades. Three diamonds suggest a cube, but there are two ways of combining them: you can see three cubes like this: one, two, three, or like this: . . . This is like an emblem that symbolizes the print's subject.

 If we divide the picture vertically into three strips, the two extreme parts are both acceptable as realities, but in many respects each other's inversion.

 In the central strip, things are uncertain and can be seen in two different ways: a floor is also a ceiling; an interior is also an exterior; concave is at the same time convex. For example: there are three little houses or chapels. The left one is seen from the *outside,* the right from the *inside,* but how is the central one to be seen? There are two flute-playing boys; the left looks down on the cross vault of the chapel; *he* sees its outside. He could climb through his window, walk over the roof, and jump down on the dark floor in front of the house. But the flute-playing boy at right, leaning out of his window, is *in*side the house; he sees that same roof as a ceiling over his head, and beneath him there is no floor, but a deep abyss.

*Compound of Five Tetrahedra*   *Stellated Dodecahedron with Engraved Starfish*

Now a new theme illustrating my interest in *regular polyhedrons*. First three objects. To the left: a cardboard model of five regular tetrahedrons intersecting one another. It presents twelve stellated concavities, each made up of five flats, which remind one of the leaves of a flower. It was this association that suggested to me the idea of making a wood sculpture. It presents twelve calyxes, which are like the twelve pentagons of a regular dodecahedron. In the center of each calyx is a pistil with stamens. These twelve pistils are the angular points of a regular icosahedron.

The right slide is a photo of a stellated dodecahedron. It is composed of seventy-two pieces of translucent perspex pasted together. A sea star is engraved on the *inner* side of each five-pointed flat. They are difficult to individualize on this reproduction but very clear on the object itself.

*Order and Chaos*                    *Crystal*

Now two prints, both symbolizing Order and Chaos. On the left: the perfectly ordered beauty of a stellated dodecahedron, combined with a translucent sphere, like a soap bubble, is surrounded by a collection of useless, cast-off, and crumpled objects. I had to make a very careful choice among the many heterogeneous objects of a rubbish dump, for every piece had to be recognizable.

The right print shows a similar idea: a transparent combination of a cube and an octahedron as a symbol of order is enclosed in a background of gravel.

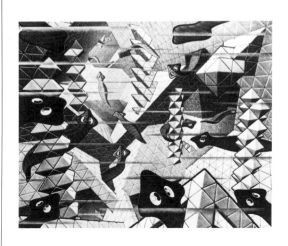

*Stars*                                                 *Flatworms*

On the left: all kinds of single, double, and triple polyhedrons are floating like stars through the air. In the center is a system of three regular octahedrons, a framework of beams. In this cage live two chameleons whose function is to add an element of life to this dead world. I chose them as inhabitants because their legs and tails are particularly adapted to grasp the framework as it whirls through space.

The right print demonstrates that one can build a house not only with our usual right-angled bricks but also with tetrahedrons alternated with octahedrons. Such a building is not suitable for human beings to live in, for it has neither horizontal floors nor vertical walls. That's why I imagine that it is filled with water, in which swim a colony of flatworms. It was amusing to build different sorts of vertical columns, all made up of alternating tetra- and octahedrons.

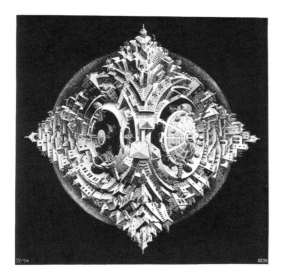

*Tetrahedral Planetoid*

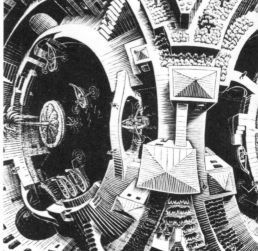

*Detail of Tetrahedral Planetoid*

Here is a planetoid inhabited by men and having roughly the shape of a tetrahedron. We see two of its faces as triangles, together forming a square. A spherical atmosphere surrounds it, through which only the corners stick out. People on these highest summits apparently still get enough air to breathe. The print has no "above" or "below"; you can turn it in any direction, for all the vertical lines are oriented toward the planet's gravitational center, and all horizontal planes are fragments of spherical shells.

You see that the people living on this lump of earth have built houses on the slopes and have cultivated the terrain by constructing terraces with vegetable gardens and fruit trees. On the lowest spots they have dug canals and ponds. An enlarged detail on the right slide shows them pottering about in rowboats. Some of them are angling and may have the luck to land a fish. Rowing through arched connecting canals, they can get from one pond to another and probably can also reach the reverse side of their world, which is invisible to us from here.

*Opposite:*
The left print shows you once again a stellated dodecahedron. It is limited by twelve flat, five-pointed stars. On each of these planes lives a tailless monster, its trunk

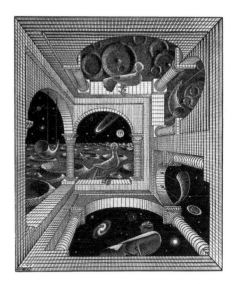

*Gravitation*

*Another World*

imprisoned under a five-sided pyramid, and its head and four legs sticking out through holes in the walls of its prison. To make clear, in this tangle of legs and heads, what belongs to what, I have given each creature its own color.

This print, being the last of my series of regular polyhedrons, may also serve as a transition to a new subject, which I call the *relativity of the function of a flat*. There is indeed already a relation between horizontal and upstanding flats in this picture. For instance, looking at the plane that is a floor for the *green* animal, we see at the same time one of its points as an upstanding wall of the pyramid that covers the body of the *yellow* animal. The same relation counts for the other flats; all are floors and walls simultaneously.

The right print is the first of a series illustrating this relativity as a main subject. It shows the inside of a cubical structure. Arched windows in its walls look out on three different landscapes. Through the upper pair one looks steeply down to the ground below; the central windows are at eye level and show the horizon, and through the lower pair we look up to the stars.

It may seem absurd to unite nadir, horizon, and zenith in one construction, and yet it forms a logical whole. Every function that we may ascribe to any plane of this building is relative. The back plane in the middle of the picture, for example, has three meanings: it is a wall in respect to the horizon behind it; it is a floor in relation to the upper prospect; and it is a ceiling in connection with the lower view of the starry sky.

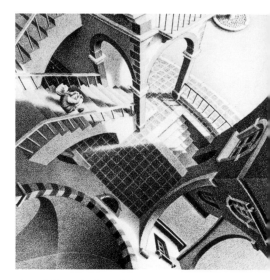

*High and Low*                              *Detail from High and Low*

Here the same idea is further developed. We see the same scene twice: in the top half of the print we look down, from a height of some three stories, on a town square with a palm growing in the middle. The lower scene offers the same view, with the same little boy sitting on a staircase and the same girl looking out through a window, but not all is seen from ground level. Casting a glance upward to the zenith, we see the tiled floor on which we are standing repeated in the center as a ceiling. For the upper scene these tiles serve again as a floor, and at the very top they are repeated a third time as a ceiling.

The right slide gives an enlarged detail of the center of the print, permitting one to appreciate the discrepancy in the right house: going down some steps, you can enter the ground floor, but if you look out of a window, you find yourself suddenly on the top floor.

*Opposite:*
Before we proceed with this relativity game, please look for a moment at the fancy animal on the left. I have always been surprised that the wheel is a human invention. When God created the world, He obviously forgot to make animals that can deliberately employ their body as a wheel or a hoop to move on. Several animals can curl up their body and assume the shape of a ball so as to protect themselves against enemies.

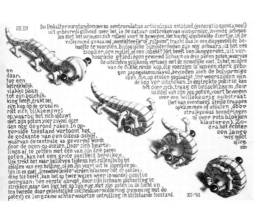

*Curl-up*

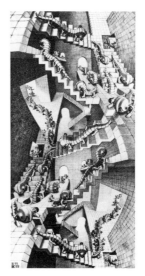

*House of Stairs*

But a coiled-up hedgehog, for instance, lies stock-still unless you give it a push or a kick. So I flatter myself to have supplied a long-felt need by designing this "roller," or "twiddle-bug" (as one of my English friends calls it). I have depicted it in four successive stages of locomotive modes: first walking slowly and cautiously on its three pairs of legs, then gradually coiling up into a compact disk, and finally rolling away and gaining speed by pushing off and tipping the ground again and again with its human-like feet. Its large eyes, placed upon stalks in the middle of its head, remain in the center while it rolls away.

The right print shows a large number of these animals crawling up and down flights of stairs. They enter and also bowl out in procession. They act to demonstrate a similar relativity, as already shown in the former prints, but a new play element is added to the game: a glide reflection of the same kind I showed you the day before yesterday in my symmetric tessellations. Almost the whole upper half of the print is a mirror image of the lower half. The flight of stairs at the top, descending from left to right, is reversed twice: once in the center and again at the bottom.

Notions of "upward" and "downward" appear interchangeable; the uppermost animal goes downstairs till it reaches a floor. Then turning to the right, it climbs up again and disappears through a gate. Meanwhile, out of a hole in the wall comes another one, which walks down. They move side by side in the same direction, and yet the left ascends and the right descends. Walls and floors also shade off into one another.

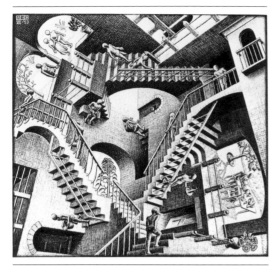

*Relativity*

*Detail from Relativity*

In this picture three gravitational forces operate perpendicularly to one another. Men are walking in crisscrosses on the floor and the stairs. Some of them, though belonging to different worlds, come very close together but can't be aware of one another's existence. Let us give some examples: in the center a fellow with a coal bag on his back comes up from a cellar. But the floor on which he sets his right foot is a wall for the sitting man to his left, and to his right is another man, coming downstairs, who lives in a third world. Another example: on the uppermost staircase (of which I show you an enlargement on the right side), two persons are moving side by side and both from left to right. Yet one descends and the other ascends.

On two other flights of stairs, persons are walking at both sides.

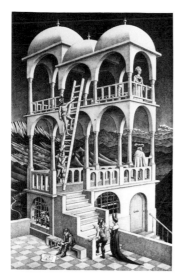

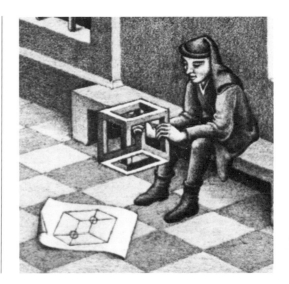

*Belvedere*

*Detail from Belvedere*

The following three prints must bring this talk to an end. Their subject matter is akin to the previous ones, but, instead of relativities, they could better be called "impossible objects."

This first one shows a belvedere with three floors, seen against a mountainous background. On the floor in the foreground lies a piece of paper (enlarged on the right slide), on which the edges of a cube are drawn. Small circles indicate the points where two edges intersect. Which of these two lines lies in front of the other depends on how you look at the cube. The boy sitting on the bench has a cuboid puzzle in his hands, which is a mixture of these two possibilities: its top and bottom are mutual contradictions. He broods over it and, with good reason, can't believe his eyes. Probably he isn't aware that the building behind him demonstrates the same impossibility. For instance, the ladder in the center, though correctly drawn according to the rules of perspective and quite acceptable as an object, stands with its base inside the house, but outside with its top. Hence the two persons on it are in an impossible relation to each other.

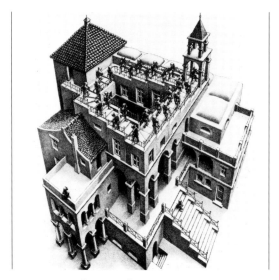

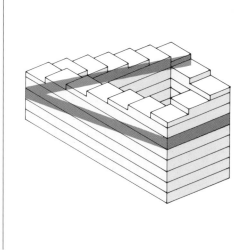

*Ascending and Descending*                    *L.S. Penrose's Staircase*

The left picture presents a complex of buildings, a kind of cloister with a rectangular inner court. Instead of a roof, it has a closed circuit of steps, a flight of stairs that enables the inhabitants to walk around on the top of their dwelling. Perhaps they are monks, members of some unknown sect. It may be part of their daily ritual duty to ascend this stairway in a clockwise direction during certain hours. When they are tired, they can change direction and descend for a while. But both notions, though not without an abstruse meaning, are equally useless. Two refractory individuals refuse to take part in this spiritual exercise. No doubt they think they know better than their comrades, but sooner or later they may admit the error of their nonconformity.

The theme of this continuous staircase is not my own invention. I owe it to the English mathematician Professor L. S. Penrose. The right slide shows a reproduction of his drawing. I have indicated with red shades a level that ought to be horizontal, which explains the trick.

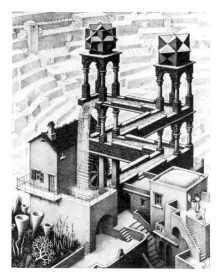

*Waterfall*                                   *Roger Penrose's Triangle*

The left slide is the last print that I can show you. The water of a fall, which sets in motion a miller's wheel, zigzags gently down through a gutter between two towers till it reaches the point from which it falls down again. The miller can keep it perpetually moving by adding every now and then a bucket of water to check the evaporation.

The towers are equally high, and yet the left is one story higher than the other. The polyhedrons on their top have no special significance. I have put them there simply because I like them so much: to the left three intersecting cubes, to the right three octahedrons.

The background is a South Italian terrace landscape, and the lower-left corner is filled with much-enlarged moss plants. The cups are in reality about one-tenth of an inch high.

The theme of this self-supporting waterfall is based upon the triangle that I show you in the right slide. As far as I know, it is a creation of Roger Penrose, who is a son of the inventor of the "continuous staircase" of the former print. It is perhaps worthwhile to quote his own words from an article in *The British Journal of Psychology* of February, 1958: "Here is a perspective drawing, each part of which is accepted as representing a three-dimensional, rectangular structure. The lines of the drawing are, however, connected in such a manner as to reproduce an impossibility. As the eye peruses the lines of the figure, sudden changes in the interpretation of the distance of the object from the observer are necessary."

Ladies and gentlemen, herewith I have come to the end of this talk. I hope that I have not tried your patience too much, and I thank you very much for the attention you have so kindly given to my fancies.

# 3

FOUR HOBBIES

By 1941 Escher had elaborated on his ideas about the regular division of planes to such an extent that he was able to present them in a clearly written exposition. It was published in the art magazine *De Delver (The Digger)* as his answer to the editors' question "How did you as a graphic artist come to make designs for wall decorations?" The question referred to his designing intaglio paneling for the town hall in Leiden.

Several elements from that succinct exposition are to be found in Escher's book *Regelmatige vlakverdeling (The Regular Division of the Plane)*, a collector's edition of 1958. In the magazine article his already well-thought-out basic principles are described, while in the book insights are expressed that have matured over a period of years. It is fascinating to compare the two, and this is reason enough to include here the article as an introduction to the text of the collector's edition (printed in its entirety), which begins on page 90. Together these two texts form an interesting addition to the material presented in the first U.S. lecture (pages 25–53).

Escher has left us still other texts about his "hobbies." Three of them are included here. It is true that the subjects were discussed in the second U.S. lecture (pages 54–80), but these are interesting additions. They are an essay about the infinite and two lectures about perspective and the impossible.

# HOW DID YOU AS A GRAPHIC ARTIST COME TO MAKE DESIGNS FOR WALL DECORATIONS?

From: *De Delver (The Digger)*, xiv, no. 6, 1941.

The board of our Association [Association for the Advancement of the Graphic Arts, called "The Graphic Arts"] posed this question and asked me to respond to it here. I could make do with the following answer, "I did not come to it as a graphic artist." My designs for wall decorations have no point of contact with my graphic work up to the end of 1937. They are related to most of the work I have done since that date. However, this work has not been created as a result of a deep interest in the graphic arts, specifically the technique of woodcut, as was the work I did up to 1937. The fact that my later work still consists principally of woodcuts is due to my familiarity with this technique. Over the years it became my mother tongue, so to speak, and I did not know another. No one asked me for another medium either, so I stuck with it as a means of expressing something that can be represented just as well, or perhaps better, in a different way.

This work of the last few years is based on a problem that can be defined as follows: the regular division of a plane into congruent figures or motifs enclosed by a continuous contour and contiguous with each other everywhere, that is, without leaving "empty spaces" of different shapes. This filling up of the plane can be continued in all directions without limitations. [1]

I can't say how my interest in the regular division of planes originated and whether outside influences had a primary effect on me. My first intuitive step in that direction had already been taken as a student at the School for Architecture and Decorative Arts in Haarlem. This was before I got to know the Moorish majolica mosaics in the Alhambra, which made a profound impression on me. The Moors use exclusively mathematical-abstract motifs for their wall and floor coverings in majolica mosaics. I assume that this is because the use of animal and human images as motifs for the decoration of planes is forbidden to them on religious grounds.

After that first Spanish trip in 1922, I became more and more intrigued by the fitting

together of congruent figures according to the above-mentioned definition and by the effort to shape these figures *in such a way that they would evoke in the observer an association with an object or a living form of nature*. Although at the time my interest extended mainly to the free graphic arts, every once in a while I came back to brain calisthenics for my puzzlings. About 1924 I imprinted for the first time a piece of cloth with one single animal motif cut in wood, which is repeated in accordance with a specific system. While doing this, I strictly adhered to the principle that no "empty spaces" may appear. In order to do this I needed a minimum of three colors, with each of which in turn I inked my stamping block so as to make one motif contrast with its contiguous and congruous repetitions. I exhibited this imprinted cloth with my other work, but it was not at all successful. Partly for this reason it wasn't until 1936, after having visited the Alhambra a second time, that I spent a significant amount of time puzzling with animal shapes. What fascinated me most of all is the double function of the line of separation between two contiguous figures. It is just as indispensable for one motif as it is for the other. Over and over again it was, and still is, a great joy to have "found" such a motif that repeats itself rhythmically in accordance with a specific system and thus obeys immovable laws. It gives one the sensation of approaching something that is primeval and eternal.[2] A rather large number of these motifs that I found and collected form a constantly growing supply from which I draw and find inspiration for the execution of compositions, of which these are the foundation. One is reproduced here (*Symmetry Work 25*).

After my second enthusiastic study of the plane decorations in the Alhambra, I initially did not go beyond searching for and sensing laws to which I submitted by necessity without knowing or understanding them. Finally it was pointed out to me by the scientific community that the regular division of planes in mathematical, congruent figures is part of the study of geometric crystallography. To the extent that my limited scientific development allowed, I studied some articles that had been published on this subject. From the start my understanding became clearer, and I began to get an overall picture of the possibilities offered by the regular division of planes. For the first time I dared to do compositions based on this phenomenon. I dared, that is, to work on the problem of expressing unboundedness in an enclosed plane that is bound by specific dimensions, while retaining the characteristic and fascinating rhythm.

The most beautiful and simple form of the unbounded and still enclosed plane is the surface of a sphere. Only after various other compositions on a flat plane did I come to use the sphere as a plane for representation. I had a beechwood sphere of fourteen centimeters in diameter made, and I worked its surface in bas-relief with a single fish motif that is repeated twelve times in a congruent shape. These twelve repetitions fill the surface completely. In order to have them contrast with one another, I stained them in four shades (*Carved Beechwood Ball with Fish*).

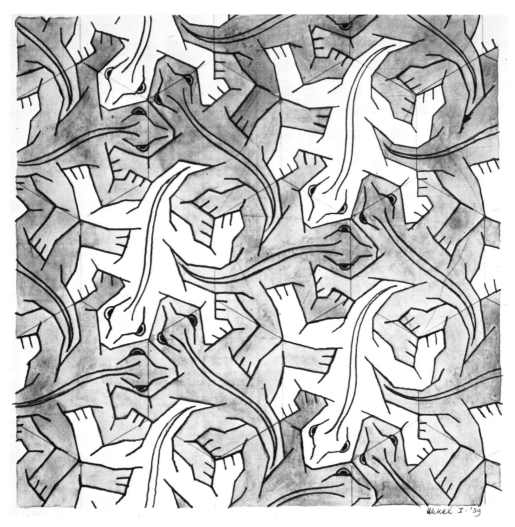

*Ukkel I - '39*

*Symmetry Work 25*

The study of regular filling of planes, using a flat plane, led me naturally to compositions that express a development, a circuit, or a metamorphosis. The woodcut reproduced here (*Sky and Water II*) represents a metamorphosis. The middle of the print is filled by the regular division of a plane with two themes or motifs in distinct shapes. These are black birds, which are all congruent in form but fly alternately to the left and to the right, and white fishes, which also alternate in image and mirror image. In an upward direction starting from the middle, the white motifs open up and lose their

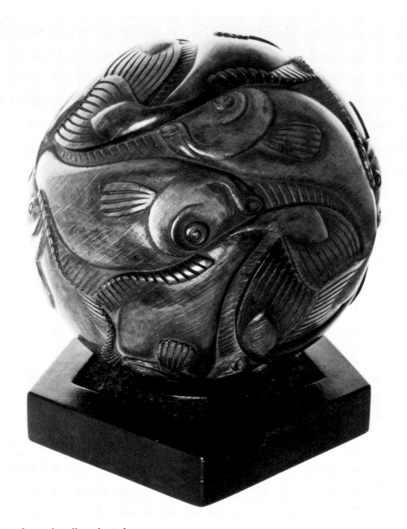

*Carved Beechwood Ball with Fish*

function as silhouettes suggesting fishes. They flow into each other and change into a background of white sky in which the birds are flying. The shapes of these birds, on the other hand, have developed more typically. The opposite happens when one moves the eye downward starting from the middle.

I dared to make another "metamorphosis," which I executed in a series of woodcuts, printed one next to the other, that together form a print four meters in length. Did I violate the graphic art of printmaking by doing this? I certainly did not make this long

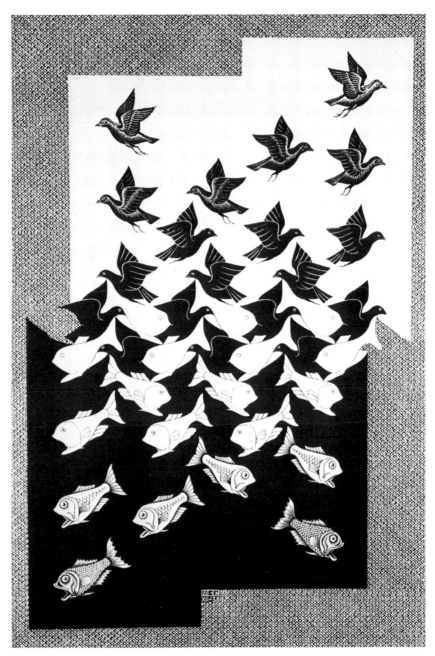

*Sky and Water II*

*Watercolor Maquette for Leiden Town Hall Intarsia Panel*

rolling print with the objective of serving the graphic technique in the first place. Rather I used the graphic technique for my own purposes.

I seized the opportunity offered to me by the request to design panels executed in the wood intaglio technique. With regard to my present work, this proves to what extent I feel liberated from the graphic arts simply for the sake of graphic arts. Of the designs I created, the one reproduced here (*Watercolor Maquette for Leiden Town Hall*) is that in which I was given the greatest amount of freedom by the people who commissioned the work. In this print, consequently, I could most truly bear witness to my interest in the regular division of planes.

Baarn, March, 1941
M.C. Escher

The De Roos Foundation in Utrecht commissioned Escher to write a book (he preferred to call it "a composition") about his hobby of division of planes. It was published as a collector's edition in 1958 with the title of *Regelmatige vlakverdeling (The Regular Division of the Plane)*. The text was also included in the edition *Leven en werk van M.C. Escher (M.C. Escher: His Life and Complete Graphic Work)*, Amsterdam, 1981.

Text and illustrations of the original edition of 1958 have been presented here in their entirety. Please note that where Escher speaks about "this book," he is referring to the original edition. The text has not been adapted; only the typography differs.

---

[1] Simple example of regular division of planes in nature: the surface of a honeycomb.

[2] Thus far, in no artistic period have I ever encountered any expression that testifies to research in a direction analogous to mine. If any readers of this article are familiar with such artistic expressions, I would greatly appreciate their bringing them to my attention.

# THE REGULAR DIVISION OF THE PLANE

A graphic artist has something of the troubadour within him. He always repeats the same song in every copy he makes of a single woodcut, copperplate, or lithographic stone. It doesn't matter much if sometimes a page gets lost, stained, or torn. There are enough copies to carry forth his thoughts. And even if they are in short supply, he can produce another series, of which each separate specimen is equally flawless, original, and complete, so long as the plate from which he is copying isn't worn out.

What a difference from the principle of uniqueness that is inherent in the art of painting! And how understandable it is that a painter often has a hard time parting with his soul child, his unique child. The best he can hope for then is loving care by adoptive parents.

The graphic artist, however, is like a blackbird that sings in the treetop. Again and again he repeats his song, complete in every copy he makes. The more copies people ask him to make, the better he likes it. He hopes the wind will spread his leaves over the earth, the farther the better — not like dry leaves in autumn but rather like feather-light seeds capable of germinating.

This graphic artist's immaterial and purely spiritual ideal is the fruitful transfer of thoughts from one human being to as many fellow human beings as possible. Isn't it remarkable and, superficially considered, perhaps also astonishing that he tries to reach this ideal by applying techniques that force him to the very material toil of a craftsman? His laborious crafting engrosses him to such an extent, and requires so much of his time and attention, that he sometimes forgets it is only a means and a medium, not a goal. This is why many makers and collectors of prints are inclined to assign an exaggerated value to pure application and to the characteristics of the old and honorable graphic techniques, which are considered almost sacrosanct. Consequently, the emphasis falls unjustifiably on process, and one hardly takes into account the actual goal of all that drudgery. No matter how much joy the exercise of a noble craft can bestow, let us not forget that it is a means of repeating and multiplying.

Repetition and multiplication — two simple words. The entire world perceivable with the senses would fall apart into meaningless chaos if we could not cling to these two

# Een

# grafi-cus heeft in zijn wezen iets van een troubadour;

*Aldert Witte, designer of the book* Regelmatige Vlakverdeling
(The Regular Division of the Plane), *played with Maurits Escher's text and image. English
translation: A graphic artist has something of the troubadour within him*

concepts. How desperate and unacceptably pitiless does the world appear to us as soon as we lose sight of them. We have to thank these two concepts for everything we love, learn, order, recognize, and accept. All the marvelous, incomprehensible, splendid, enchanting laws that surround us are dependent on them. The entire world is maintained by them. If we should lose them, at that instant the universe would break apart like a bomb. (Mutation, meaning "change of form," is not forgotten here and will be discussed later.)

Repetition and multiplication. These will lead us, in a narrower sense, to the subject of this composition, the regular division of a plane. A feeling of helplessness comes over me now that I am faced with describing what is meant by this designation. In this book it is not the words but the images that are of primary importance. (The designer responsible for the typography has apparently also wanted to emphasize this with his imaginative game of letters in the illustration on page 91 because for him, too, the thoughts expressed in words are not of primary importance. He adds his personal approach to division of planes to mine and expresses it, just as I do, in representations for which he uses the letters themselves as figures and signs of recognition. And he does this without worrying about their literary function, just as I handle animal forms as beacons without troubling myself about their biological meaning.) It is not part of my profession to make use of letter symbols, but in this case I am forced to. However, I have not received any training for this, as I have in the use of illustrations that serve as a means of expressing thoughts in a more direct way than the word. Still, my images require explanation because without it they remain too hermetic and too much of a formula for the uninitiated observer. The interplay of thoughts they translate is essentially completely objective and impersonal. To my unending amazement, however, this is apparently so unusual and in a sense so new that I am unable to identify any "expert" in addition to myself who is sufficiently comfortable with it to give a written explanation.

It remains for me an open question whether the game with little white and black figures, as revealed in the six woodcuts of this book, belongs to the domain of mathematics or to that of art. If it may be considered art, why is it that, as far as I have been able to determine, no artist has ever occupied himself deeply with it? Why am I the only one who is fascinated by it? Never have I read a word by any artist, art critic, or art historian about the subject that we are discussing here. No encyclopedia of art history, no colleague of this period or of the past has ever been involved with it. Sporadically we find some decorative products that have sprung forth from the same trunk, which I shall discuss later on. However, these are rudimentary and embryonic and do not testify to an in-depth consideration, so they do not penetrate to what I consider the nucleus of the matter.

Mathematicians have theoretically mapped out the regular division of a plane because this is part of crystallography. Does it therefore belong exclusively to mathematics? I do not think so. Crystallographers have given us a definition of the concept and have researched and determined what and how many systems and methods exist for dividing a plane regularly. By doing this they have opened the gate that gives access to a vast domain, but they themselves have not entered. Their nature is such that they are more interested in the way the gate is opened than in the garden that lies behind it. Let me continue with this analogy for a while. Long ago during my wanderings I happened to come into the neighborhood of that domain. I saw a high wall and, because I had a presentiment of something enigmatic and hidden that might lie behind it, I climbed it with difficulty. However, on the other side I landed in a wilderness through which I had to make my way with much effort until I arrived via detours at the open gate, the open mathematical gate. From there well-cleared paths extended in various directions, and since then I often spend time there. Sometimes I think I have covered the entire domain and trod all the paths and admired all the views. Then all of a sudden I find another new way, and I taste a new delight.

I'm walking around there all by myself, in that splendid garden that is in no way my property, the gate of which stands wide open for everyone. I spend time there in refreshing, but also oppressive, loneliness. That's why for years now I have been bearing witness to the existence of this pleasure ground and why I am composing this book of images and words, without expecting in the end that many strollers will appear. Because what fascinates me, and what I experience as beauty, is apparently considered dull and dry by others.

The designation "regular division of the plane" is not, as already noted, a concept that makes further clarification superfluous. It suggests to the reader who is interested in art—if I may be so bold as to observe a relationship to art—nothing with which he is familiar, as would be the case, for example, with such words as "expressionism," "still life," or "palette knife," just to mention some completely disparate and arbitrary concepts.

Consequently I must try to arrive at a definition, and I will do so as follows: *A plane, which one must imagine as extending without boundaries in all directions, can be filled or divided into infinity, according to a limited number of systems, with similar geometric figures that are contiguous on all sides without leaving "empty spaces."*

Let me clarify this definition for the moment by using simple examples that will appeal to everyone.

A floor can be covered, inlaid, or filled with tiles, all of which have the same form and size. In the majority of cases, these tiles are square. This is also the simplest imaginable example of regular division of planes, namely, two identical sets of straight

parallel lines that intersect each other at an angle of ninety degrees. Using this example as a starting point, one can imagine a series going from simplicity to complexity in types of systems for division of planes. This can be done by consecutively using as elements tiles in the shape of squares, oblong rectangles, rhombs, triangles, and hexagons. It is clear that a filling with hexagons is already considerably more complicated and based on a less simple system than a composition constructed of squares. However, all these figures satisfy the requirement that was posed in the definition. They can be fitted together in such a way that no space remains between them. In other words, the layer of mortar, which separates them in practice and which is applied by the mason in order to make them stick together, can theoretically be reduced to nothing.

This exposition is, of course, not meant to initiate the reader into the number and characteristics of all the systems researched and recorded by crystallographers specializing in this. Just as I do not consider it necessary to know all the tricks of the graphic trade in order to appreciate prints, neither do I believe that one must master in detail the theoretical fundamentals of the division of planes in order to learn to value this and to accept that it can exert an inspiring influence, as I have experienced.

Let me use the first image here to complement and elucidate the one-sidedness of my words. In *Regular Division of the Plane I* (page 97), a process of development takes place. The viewer is invited to follow this by going through the phases, one after the other, of a band of images that starts at the upper left and fills the image plane in a zigzag manner through twelve stages of growth and metamorphosis, which I will describe in sequence.

1. The beginning is gray. The method applied by graphic artists, at least when we do not use colors, is generally to print a woodblock by means of black ink on white or practically white paper. I have serious objections to this method, even though I myself have been using it for years. My objections concern the inconsistency of the fact that even before we start, one of the two contrasting elements, white or black, is already present. This notwithstanding, we pretend to be creating *both*. But white already exists and, furthermore, it continues in the unimprinted margin of the paper around the print itself. As a consequence, the balance between the two components of the white-black contradistinction is disturbed. In the case of a free graphic print, this may be annoying. However, it becomes simply unacceptable for representations that relate to regular division of planes because in these, as will become apparent later on, the white and the black elements have completely equal value. How much more logical it would be, at least in theory, to print on gray paper with white as well as black ink. Unfortunately the practical objections are too great. First of all, when covering dark paper with ink of a lighter color, one runs into technical difficulties that make it almost impossible to obtain a beautiful, clear white. Second, the whole procedure would require twice as much

time and effort because two blocks instead of one would have to be cut, one for the white elements and one for the black. Therefore, the customary procedure was followed for production of the six woodcuts in this book. For each print only one block was cut and then printed with black ink on white paper. But in order to accommodate my explicit request, the edges around the prints were printed over in the text with a gray shade that approaches the midpoint between black and white as closely as possible. In my opinion, this method of printing considerably improves the balance of the contra-distinctions.

Whenever we are faced with a process of development, therefore an action, as in this woodcut, one can ask the question "Was there already something before 'the story' began?" Isn't it plausible to accept "gray" not only in a static sense, as we tried to do earlier, but also in a dynamic sense as the origin of the contrast between white and black that develops from it? In this way then I consider the indeterminate, nebulous, gray plane as a means of conveying static rest. I see it as a means of representing the timelessness, the dimensionlessness that existed before life commenced and that will return when life again ceases. I see it as a formless element in which the contrasts will again dissolve, "after death," if one wants to express it that way. For this reason, too, it is good that all black-and-white prints in this book are surrounded by a neutral gray shade.

2. From the indeterminate mists of gray loom two sets of straight parallel lines. They act as guides for the division of the plane. By means of the distance between them and the angles at which they intersect each other, they already unveil a part of the character of the figures that will grow out of them later on. Specifically the size of the surface of each of them is already completely determined by the four sides of each parallelo-gram. This will remain constant throughout the changes in form that are soon to follow.

3 and 4. The two sets of straight lines intersecting each other, which appeared in the previous stage, are an abstract fiction. Visual delineation or limitation does not happen by means of "lines," but through a contrasting action among planes of various shades. Thus here, too, the contiguous figures must actually be separated from one another before they develop further. We already know with certainty that a minimum of two contrasting shades is in this case sufficient to obtain that effect because each time four figures touch one another at one point. That is not always the case. On a floor filled with hexagonal tiles, not four but three hexagons meet one another at one point. In that case a minimum of three shades is needed to separate them visually from one another. However, two shades are sufficient here, white and black, which have grown to maximum contradistinction at the end of plane 4.

5 and 6. At the beginning of plane 2, we have chosen, out of an infinite variety of

possibilities, a specific division in parallelograms. Now, at the start of plane 5, we stand for the second time at a crossroads. Out of three principles of division of planes, one has to be chosen so that we can get closer to our ultimate design. These three principles, for the sake of brevity, may be given the terms "translation," "axles," and "glide reflection." I shall illustrate their characteristics further as the occasion arises in the text. In the present case my choice went to "translation" as being the simplest of the three roads lying before us. The straightness of the lines in the white-and-black boundaries of plane 4 changes slowly in 5 and 6, where they curve and crack increasingly. What appears as a bulge for "white" is an indentation for "black."

7. In this plane the steady growth of the figures has come to an end. They have reached their definitive form and will maintain this until the end of the band of images. At first, it looks as if nothing is left of the original parallelogram. In fact, however, its characteristics have definitely been preserved in the completed small figure or "motif." For example, the surface of each motif is still identical to that of the former parallelogram. In addition, the points where the four figures meet remain on the same spots in relation to one another.

The translation principle with which the division of planes complies can now be described as follows. When one imagines that each of the white and black motifs is a small, flat object punched out in cardboard or sawed out of wood and that together they form a "puzzle," then it is possible to lift one specimen carefully out of the mosaic. By now executing a movement in a straight line with the hand that holds the piece, parallel with the plane of the jigsaw puzzle, one can place it strictly by the process of "translation" on top of any other piece in such a way that they cover each other completely. Translation therefore means that the placement of figures on the image plane in relation to each other continues to be the same.

The white and black silhouettes have taken on a specific, not an arbitrary, form because the process of their development has intentionally been directed toward creation of the now definitive shapes. To the extent allowed by the strict discipline and extreme limitations of the system for division of planes here applied, an attempt has been made to create a form in such a way as to enable the observer to "recognize something in it." I suppose he gets the impression, in a vague and undefined way, of its having to do with something that floats, something that has a rump and two wings or fins partly coinciding with each other, thus probably a bird or a fish.

8. This uncertainty ends as soon as we fill the black silhouettes with a few simple detail lines. Now there is no longer room for error. We see black birds flying against a white background.

9. It can of course be done just as well the other way around. By removing the detail

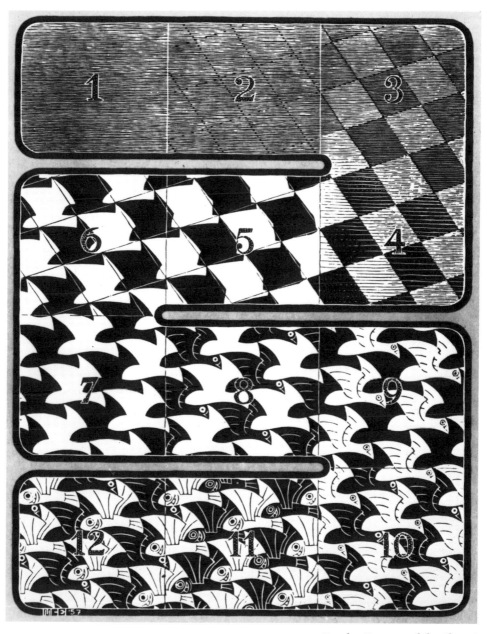

*Regular Division of the Plane I*

lines from the black and putting them into the white motifs, the representation changes into its opposite, and the white birds become visible against a black background.

In 8 and 9, therefore, something remarkable has happened by drawing a few simple lines. All of a sudden a suggestion is created of relief, of depth, of "nearby" and "far off," of foreground and background. These notions were still completely absent in the first four planes. There at most we thought of the concepts "floor" or "wall," but the two-dimensionality of the plane was not broken. Propelled by an associative impulse, we can even go one step further and arrive by way of the series background-white-sky at "day" in plane 8 and at "night" in 9.

10. A regular division of planes that is complete within the meaning I attach to it is created only when all congruent figures fulfill the function of "object." After we have followed this band of images to the end, I will discuss the question of whether in that case it is still possible to talk about "background."

11. In this particular example we can also translate in a different way the white and black stains which in our thoughts we have made into birds. By moving the eye and the beak from right to left and by allowing a fin to replace a wing, our birds become fishes.

12. And finally, of course, we can just as well combine the two species of fauna in one plane filling. In the solution here presented black birds fly toward the right and white fishes toward the left, but we can interchange them according to our wishes.

This ends the story of our first print. It has thus become clear that a succession of gradually changing figures gives rise to the creation of a story in images. In a similar way pictorial artists of the Middle Ages told the life story of a saint in a series of static scenes. Each of these scenes depicted an important moment in the saint's life, and together they told their story in an overall frame, whether they were in separate compartments or in one continuous landscape. The spectator was expected to observe the individual phases in sequence. The series of static representations achieved a dynamic character due to the time span that was needed to follow the whole story. In contrast to this are the cinematographically projected images of a film, which appear one after the other on an immovable plane, onto which the viewer's eye remains directed without moving. In the case of both the medieval story in images and the developing pattern of a regular filling of a plane, the images are located next to each other, and timing becomes a factor in the movements made by the viewer's eye as it follows the story from image to image. In this way, holding a strip of film in the hand, one observes it image by image. Reading a book is also done more or less in the same manner.

Now that it has become clear that a plane can be completely filled with or constructed out of figures that individually represent recognizable objects, the question arises as to whether all of them can be seen simultaneously as objects. Is it possible to make a representation of recognizable figures that has no background? Based on my many years of training in the composition of lines that demarcate motifs of equal value, I thought I could answer that question in the affirmative until it was brought up in an exchange of letters with the ophthalmologist J. W. Wagenaar, who from a scientific and philosophic point of view can judge this matter better than I. From his writing I quote the following:

. . . in my opinion, it is not right that you make representations without backgrounds. These are compositions in which background and figure take turns changing functions. A continuing competition exists between the two, and it isn't even possible to continue seeing one element as figure. Irresistibly the elements functioning originally as background present themselves cyclically as figures. Just as when we, for example, with a red glass in front of one eye and a green glass in front of the other, see the world as neither red nor green but in a color that constantly changes from red to green and back (that is, if both eyes see equally well and there is no distinct dominance by one eye!); in the same way, there is no visually static balance in your compositions but rather a dynamic balance in which, however, the figure-background relationship exists for each phase. Only one static balance is possible, and that is when one sees the entire figure as pattern and therefore frees oneself from the notions of "bird" and "fish."

To see only a "figure" is not conceivable because something that manifests itself as figure, that is, as "thing to be seen," is limited, whether it is real or not. A limitation means a separation with regard to something else. That "something else" is the background from which the figure (or object sensation) frees itself. To see ground only is indeed possible, for example, while standing in a fog or while located in an Ulbrich sphere. This is an apparatus manufactured for experiments testing the physiology of the senses and consisting of a large sphere, painted a dull white on the inside, in which an experimenter can place himself. The lighting is diffuse and the eye has no place on which to rest.

Thus says my correspondent. His clear exposition contributed significantly to my understanding of the regular division of planes and could, therefore, not be omitted from this text.

Although two contiguous units apparently cannot be conceived of by us simultaneously as "figure," nevertheless the form and character of both are determined by one line of separation. This line thus has a double function. In this exceptional and strange method of drawing, impulsiveness and spontaneity are understandably completely absent. With much patience and continuous weighing of the pros and cons and generally only after an almost endless series of failures, one finally creates a line out of all of this that looks so simple that an outsider cannot imagine with how much effort it was obtained.

Imagination and inventiveness, not to mention tenacity, are indispensable for this work. They come to us from "somewhere out there," but we can facilitate their path to us and encourage and cultivate them in various ways. Among others, I found one suggestion in the writings of Leonardo da Vinci. This is the fragment, translated as best I can: "When you have to represent an image, observe some walls that are besmeared with stains or composed of stones of varying substances. You can discover in them resemblances to a variety of mountainous landscapes, rivers, rocks, trees, vast plains, and hills. You can also see in them battles and human figures, strange facial features and items of clothing, and an infinite number of other things whose forms you can straighten out and improve. It is the same with crumbling walls as it is with the sound of church bells, in which you can discover every name and every word you want."

This advice of Leonardo's is certainly useful for stimulating inventiveness and imagination in general. From experience, however, I have found it particularly valuable when designing regular fillings of planes because this is largely a matter of putting chaotic forms in order and making abstract forms concrete.

Despite all this conscious and personal effort, the illustrator still gets the feeling that some kind of magic action is taking place as he moves his lead pencil over the paper. It seems as if it isn't he who determines his shapes but rather that the simple, flat stain with which he is toiling and tinkering has a will or unwillingness of its own. It's as if the stain is guiding or impeding the movements of the hand that draws, as if the illustrator were a spiritualistic medium. In fact, he is amazed, not to say taken aback, at what he sees appearing under his hand, and he experiences with regard to his creations a humble feeling of gratitude or of resignation, depending on whether they behave willingly or reluctantly.

As the preceding pages have covered the problem of regular division of planes from different angles with reference to woodcut I, I now want to discuss the rest of the illustrations. While doing this, I shall bring up various other aspects. I recognize that by proceeding in this way my composition will seem improvised and without systematic construction and format, but what else can one expect from a graphic artist for whom words are inferior to images? Image-related thoughts are of a different order from literary thoughts. Consequently the reader will have to be satisfied with a more or less arbitrary sequence of considerations, which I shall record in the order in which they come to mind as I observe the prints one by one.

I have divided *Regular Division of the Plane II* (page 105) into four horizontal bands, the uppermost band again divided into three square compartments, A, B, and C.

I copied A and C in the Alhambra near Granada, Spain. They are decorative wall coverings built up out of small, similarly shaped, contiguous majolica tiles that together form a colorful mosaic. I chose these two from the large variety of patterns that sparkle

and glitter there on floors and walls. I chose them not only because they are good examples of what one could call regular filling of planes in a primitive stage but also because the arrangement of colors in which they were executed could be transferred to white and black without difficulty—something that cannot be done with most of the Alhambra designs. I found pattern B, executed in woodcut technique, in a small Japanese book. I don't know if it was Japanese originally; it could just as well be Chinese. It is very well known and is often represented, usually in the form of an outlined figure, without a clearly defined shape, in contrasting shades. The specific character of a plane filling in primitive stage, however, shows up more distinctly when the motifs are alternately white and black. The primitive stage in which all three of these divisions of planes appear, with which designation I mean their abstract-mathematical character, makes it difficult to discover in each of them the characteristics of a particular national character. B perhaps seems somewhat more Oriental than A and C. It seems probable that B was created from the observation of basketwork, as a result of which it evokes a plastic impression. I have often asked myself why the designers of these patterns, in their desire for decoration, have never, as far as I know, crossed the boundary from abstract motif to recognizable representation. This does not diminish the beauty and ingenuity of their discoveries, in which more and less complicated systems, for example, can already clearly be recognized. In C, more clearly than in B, the principle of "axes" appears, which I shall describe in more detail later. But why did they never get to the point of further elaborating a thought association when it occurred? The little figure in pattern C in particular reminds me of "something that I know," a hammer, a bird, a plane.

Since it is exactly this crossing of the boundary between abstract and concrete representation, between figures that are "mute" and figures that "speak," that leads to the nucleus of what I find most fascinating in the regular division of planes, it is important to investigate whether there are perhaps reasons why this is not encountered anywhere.

I know of two cultures in which, for religious reasons, people were not allowed to make "representations": those of the Jews and the Mohammedans.

In the second of his Ten Commandments (Exodus 20:4), Moses forbade his people to make images. In the clear and sober language of the Leiden translation, this commandment reads: "You shall not make any images, no shape of anything that exists in the heavens above or on the earth below or in the water underneath the earth." What I find especially striking is the emphasis on what exists "in the water underneath the earth," because fishes lend themselves so well as motifs for my plane fillings. It is less clear, perhaps not at all clear, as to whether the phrase "anything that exists in the heavens" refers to birds. This may refer to sun, moon, stars, and clouds.

As far as I know, practicing Jews have in general always kept this commandment.

Consequently, only with difficulty can Jews who are visual artists be really faithful to the laws of their religion. With regard to the Mohammedans, I have made inquiries to someone with a much greater knowledge of this subject than I. From his letter I quote the following: "I have found an article by the great Islam expert Professor C. Snouck-Hurgronje (in his *Verspreide Geschriften [Scattered Writings]*, II, pp. 453 et al.), from which I understand that the Koran does not forbid the representation of living beings. However, it is based on the sacred tradition (*hadith*), which says, 'He who makes images (representations) shall undergo the severest punishment on the day of resurrection,' which therefore refers to those who manufacture images. On the other hand, there is a pronouncement about the presence of these in dwellings and similar buildings, which goes as follows, 'The angels of mercy do not enter into dwellings in which images are to be found.'"

The orthodox writings endorse these rules completely. They describe the making of images of loved ones or respected persons as abominable, since this is the root of idol worship. Furthermore, the representation of beings who have been created is, as it were, an imitation of the work of the creation and can therefore be no more than a caricature. Such a presumption is an injustice in the eyes of God, and on the day of resurrection these hapless makers of images will be required to blow life into their creations. This is the theory. However, in practice things are different, and even the various law books make concessions. In general they state that the use of a representation is not forbidden if it is intended to be treated or touched without respect—for example, representations on rugs on which one walks or on pillows on which one sits, or in corridors, so that it is impossible for them to become objects of worship. This applies, consequently, to the user, *not* the maker. For the maker, the rule applies in all its severity.

In countries such as Persia and India, these commandments have been applied with considerable leniency. I am not familiar with the situation, however, in countries where the teachings have been adhered to more strictly, such as Arabia and probably Spain in the Moorish period. In Persia and India there have been representations not only of all kinds of animals but also of people, even the Prophet, not to mention monarchs, generals, highly placed officials, etc., even though this largely occurs in the painting of miniatures.

So the prohibition was not in the Koran but in the tradition, with regard to the maker and the user. The prohibition forbade representing *living* beings because this would be incompatible with conceptions about the work of the Creator, which cannot be equaled by any earthly mortal beings, and because this would lead only to caricatures.

I don't believe any precepts exist that forbid the making of images for people other than the Jews and the Mohammedans. The Japanese and the Chinese, for example, did not

have any obstacle, as far as their religion is concerned, preventing them from crossing this threshold, as demonstrated in A, B, and C of woodcut II illustrating the beginning stage of regular division of planes. And yet neither they nor any other people interested in decoration have ever done so, as far as I know. Even this primitive phase has not been reached by most cultures. Perhaps they have never searched for the division of a plane using strictly similar figures, let alone attempted the embryo-type fillings with regular polygons, squares, triangles, and hexagons that are often found on our floors and walls. It is therefore doubly unfortunate that the Moors were the only people who apparently were strongly intrigued by this, yet were not allowed to go beyond abstractions, putting aside the question of whether they ever wanted to go further.

As stated earlier, I'm walking around all by myself in the garden of regular division of planes. No matter how much satisfaction may be derived from possessing one's own domain, the loneliness is difficult to bear. In this case, it also seems to me really impossible. Every artist (it would be better to say every human being so as to avoid the word "art" in this context as much as possible) possesses all kinds of highly personal characteristics and idiosyncrasies. But the regular division of planes is not a tic, an idiosyncrasy, or a hobby. It is not subjective but objective. No matter how much I try, I cannot accept the idea that something so obvious as making small complementary figures recognizable and giving them meaning, function, or purpose would never have occurred to anyone other than me. In fact, only when we cross the threshold of the primitive stage does the game acquire more than just decorative value.

Long before I discovered in the Alhambra that the Moors had an affinity for the regular division of planes, I had already recognized it in myself. In the beginning I had absolutely no idea of the possibility for constructing my figures systematically. I did not know any of the "rules of the game," and I tried, almost without knowing what I was doing, to fit together small congruent planes and to give them the shapes of animals. As a result of reading technical literature, to the extent that is possible for someone without an adequate mathematical background, I found the designing of new motifs slowly becoming a little less difficult than at first. The main reason for this was my formulation of a layman's theory, which forced me to think about the possibilities. However, designing new motifs still remains an extremely strenuous activity. It is a real "mania" to which I became addicted, and from which I can hardly tear myself away sometimes.

How slowly one advances in a boat that does not float along with the stream in a specific direction! How much easier it is when one can connect with the work of great predecessors whose value is not doubted by anyone. A personal experiment, a construction whose foundations one must dig himself and whose walls one must erect himself, runs a real risk of becoming a humble hovel. But perhaps one prefers to live there rather than in a palace that has been built by others.

Before I go on to separate discussions of the following representations, I want to explain the method used in all the prints, except in VI, to illustrate the various systems clearly. In each, three phases can be distinguished. There is a beginning stage that shows the opposite image of an end stage, that is, a white object on black ground on the one hand and a black object on white ground on the other. In between is the mid-stage, which is the real, complete division of a plane, in which both opposite elements are equivalent. In 1, 2, and 3 of II, the three phases flow into each other horizontally, that is, the end stages are located to the left and right of the center. In III, IV, and V, the transfer has been achieved in a vertical direction in order to provide some variation.

We continue with *Regular Division of the Plane II* and observe bands 1, 2, and 3 consecutively.

The beetle in band 1 is again a case of translation and therefore similar to the fishes and birds of woodcut I. However, it is symmetrical on two sides. One looks at it from above, from a direction perpendicular to the plane on which the beetle is thought to be located or to be moving. On the other hand, the figures of woodcut I were asymmetrical and seen from the side. With regard to these vertical and horizontal observation points, let us pause here to ask the question "Which 'things that one recognizes' lend themselves best to being represented as motifs of a regular plane filling?"

First of all, they must have a "closed form"; it must be possible to capture their entire shape within a closed outline; they must be detached objects. This already greatly limits the choice among the infinite number of different forms that surround us. For example, plants, which figuratively and literally are more strongly attached to the earth than animals, do not lend themselves well to being objects for division of planes because it is difficult to represent them without showing whatever they attach themselves to. Thus parts of plants, a flower, or a leaf (unless fallen to the ground) are also not typical figures for division of planes because they are bound to concepts such as stem, stalk, branch, and trunk.

Second, the outline that surrounds their form of appearance must be as characteristic as possible. It ought to identify the nature of the object clearly. The effect of the silhouette must preferably be so strong that one recognizes the object even without many internal detail lines, which always act in a disturbing way with regard to the figure as a unity.

Third, the outline must have no indentations and bulges that are too shallow or too deep. These also make the figure as a whole difficult to distinguish. The contiguous black and white elements must be easy to separate from each other without too much effort for the viewer's eye. Thus the beetle in band 1 is a border case. The sequence of white and black legs would, if each were a little thinner or longer, turn into a gray hatched plane, and each leg separately would be difficult to distinguish as part of a specific beetle's body.

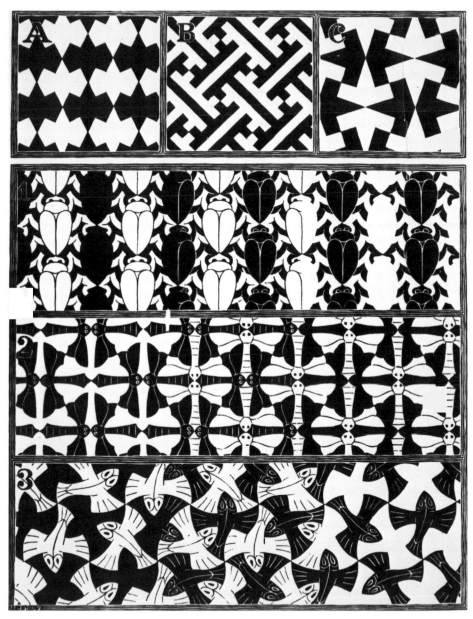

*Regular Division of the Plane II*

Motifs for division of planes that satisfy all three of these conditions are scarcer than one would think.

Inanimate objects that are recognizable as a specific and known thing almost always belong in the category of utilitarian manufactured items. Their silhouette is generally too simple, too straight, or bent with too simple a curve; in other words, the line is not capricious enough. They are also frequently symmetrical on two sides, and although this in itself does not always present a problem, as the beetle motif demonstrates, it is still a reason why their shapes are generally unsuitable in practice for the game of division of planes.

Most useful of all are the shapes of living beings. In the case of an animal shape, however, the question immediately arises, "From which side should I look at it so as to see its silhouette in as characteristic a way as possible?" Four-footed mammals are usually best recognized by looking at them from the side. Reptiles and insects, on the other hand, generally present their most typical aspect when seen from above, while the human figure is at its most characteristic when viewed from the front.

Experience has taught me that, of all living creatures, the silhouettes of gliding birds and fishes are the most gratifying forms for playing the game of plane filling. The silhouette of a flying bird has just the required angularity, and the indentations and bulges of the outline are neither excessively nor insufficiently pronounced. In addition, the bird's aspect is typical both from above and below, as well as from front and side. A fish is hardly less suitable; only from the front is its silhouette immediately un-serviceable.

In the dragonfly motif of band 2, we encounter the second of the three principles of plane division, which I briefly designated earlier as "axes."

While the beetles in band 1, both the white and the black ones, were shown in the same vertically climbing position, the situation is different with the dragonflies. On the left side of their band they appear as black objects on a white background, with their body axes in a horizontal position, directed in turn to the left and to the right. On the right end of the band they appear as white figures in a vertical position, with their heads in turn toward the top and the bottom. They have turned themselves around at a ninety-degree angle with regard to the black ones, but the white as well as the black ones turn themselves 180 degrees with respect to one another.

One can best imagine these two turning movements by assuming that we have made two identical photographic slides of the complete middle section on transparent film. When the film is placed on a lighted tray, we look through the white elements while the black are opaque and thus dark. We lay the films on top of each other so that the white of the top ones fits completely over the white of the bottom ones. The dark parts also cover each other completely. At a point where four dragonfly wings touch one another, we stick a sharp needle straight through the two film planes down into the illuminated background. Now we hold the bottom plane completely still and rotate the top one

slowly, using the needle as axis. At first a kaleidoscopic effect is created of white and black spots that double themselves and change shape continuously. The quantity of black increases gradually and the white decreases until the moment when we have completed a quarter rotation. In other words, when the top film has been rotated exactly ninety degrees with regard to the bottom one, all the white spots have disappeared; all the figures cover each other again, but now with the understanding that every white dragonfly is completely covered by a black one. If we continue and make one more quarter rotation, white and black will then be equivalent again as at our point of origin. In this way we pass, during one complete circle rotation of 360 degrees, four moments in which the motifs cover one another completely; such an axis is, in fact, called a "quaternary" one. If, on the other hand, we stick the needle through the films at a point where two heads and two tails come together, there will be not four but only two covering moments during a complete rotation of the axis, and they will be situated in diametrically opposite positions; here we have a binary axis.

The flying fishes of band 3 also fill the plane in accordance with a system of axes, which is, however, different and more complicated. While the basic figure of the dragonfly filling was a square, here it is an equilateral triangle. And instead of two different axes, here we find three: a binary, a ternary, and a sesternary. The way they alternate with each other on the plane is easier to draw than to explain, which is why I have represented it graphically in *Figure 1*, page 108. Here three sets of heavy parallel lines have been drawn, which intersect one another at angles of sixty degrees and thus divide the plane into equilateral triangles. The binary axes have been indicated by oval-shaped little figures or symbols, which are located at the midpoint of one side of each triangle. Small triangles indicate the location of the ternary axes and small hexagons those of the sesternary ones. In each fish, therefore, are to be found two ternary axes, one binary, and one sesternary. After my discussion of the rotations of the dragonfly filling, it won't be difficult for the reader mentally to place his needle axis at the various rotation points and describe circle arcs of 180, 120, and 60 degrees, respectively.

Although the filling of the plane in band 3 occurs in a way that is no less regular than in bands 1 and 2, the six attitudes of these flying fishes create the appearance of a greater freedom, a playfulness, and a spontaneity. This is not only because of the absence of right angles but also because the figures themselves are no longer symmetrical on two sides. Whoever has a feeling for the peculiar beauty of the regular division of planes will experience more joy from this last example than from the two previous ones.

In *Regular Division of the Plane III* (page 110), the third principle of plane division, glide reflection, comes up for discussion. Here all the figures from which the plane is

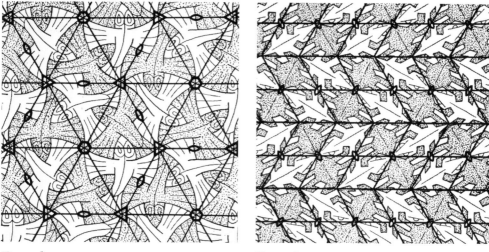

Figure 1                    Figure 2

constructed are also similar in form, but the black horsemen are congruent only with respect to each other, as are the white ones among each other. Congruence, in fact, means that the figures can cover each other without leaving the plane. An open left hand and right hand, for example, are not congruent, but they are similar in form. Examples of congruence were bands 1, 2, and 3 in woodcut II, where the figures could be slipped or rotated onto each other without disturbing the two-dimensionality. If, however, as in the case of these horsemen, motifs occur that repeat themselves in mirror image, one of the two has to go into the third dimension in order to make it possible for all to be covered. It must leave the plane for a moment, be turned over, return to the plane with its underside up, and, thus having become congruent with its former mirror image, be slipped on top of it. The term "glide reflection" renders this action succinctly.

An example of glide reflection is also illustrated in *Regular Division of the Plane IV* (page 111). There is, however, an essential difference between the system in accordance with which the watchdogs complement each other in image and mirror image and the system of the previous woodcut. All the black horsemen ride, in rows one above the other, from right to left; all the white ones from left to right; here white is always mirror image of black. But in woodcut IV each horizontal procession of congruent dogs facing in the same direction alternately includes white and black ones, so that motifs of one and the same color are also each other's mirror image.

Finally *Regular Division of the Plane V*, page 113, shows an example of glide reflection

combined with axes, while also two figures of differing form are repeated on the plane. Both are reptile-like with a head, tail, and four legs, but the black ones are compact in shape, broad and short, while the white ones are long and narrow. Yet another case of division of a plane with two motifs of dissimilar shape is applied in the design fragment illustrated on page 115. A light and a dark bird are repeated there in accordance with the principle of translation. In woodcut V, however, the reptiles complement one another in a complicated way that, again, can be better explained in a schematic illustration (*Figure 2*) than with words. The original forms are rhombs. The reptiles are represented as bilaterally symmetrical. (They only appear to be symmetrical, however, as is clearly shown by comparing a left and a right rear leg of the white animals.) The long rhomb diagonals are body axes for the white reptiles, the short ones for the black. Two horizontal tracks of rhombs together repeat themselves each time turned over in mirror image — glide-reflected, one might say. The axes here are strictly binary and are again indicated by a small oval sign. They are located on the intersection points in the center of each set of two glide-reflecting tracks.

Before discussing the remaining print material, we must say something here about the application of the regular division of the plane to horizontal and vertical planes.

Horizontality and verticality are concepts so inherent to our life on earth that we are barely conscious of them anymore. The mystery of gravity dominates all our comings and goings on the spherically arched surface of our mother earth. In the natural phenomena around us we continually encounter the vertical, for example, in a tree that propels itself straight up out of the earth or in the thread on which a spider lowers itself, and the horizontal, for example, in the surface of the sea and that of a mud puddle. Even man as builder, architect, is nothing more than a servant, a slave of gravity. And even the decorative artist intent on filling the plane is again and again inescapably confronted with the choice between vertical walls bound by right angles and horizontal floors and ceilings in order to give visual expression to his ideas. He must consequently ask himself what can be represented better vertically and what horizontally.

Earlier we discussed the directions from which an animal displays its most characteristic silhouette: "from above," "from below," "from the side," and "from the front." It is clear that a bird seen from below outlined against a background of clouds or blue sky lends itself better to representation on the ceiling than on the floor of a room. A fish, on the other hand, which is observed in the water when one leans over the parapet of a bridge or the railing of a ship, is best suited to representation on a ground surface rather than on a ceiling. Both examples suggest horizontality, but this does not prevent these representations, directed toward the highest and the lowest points, from being frequently and without much objection created on walls because our imagination is flexible enough to accommodate this. It is different with animals observed from the side or from the front. For them it is definitely preferable, almost necessary, to have a

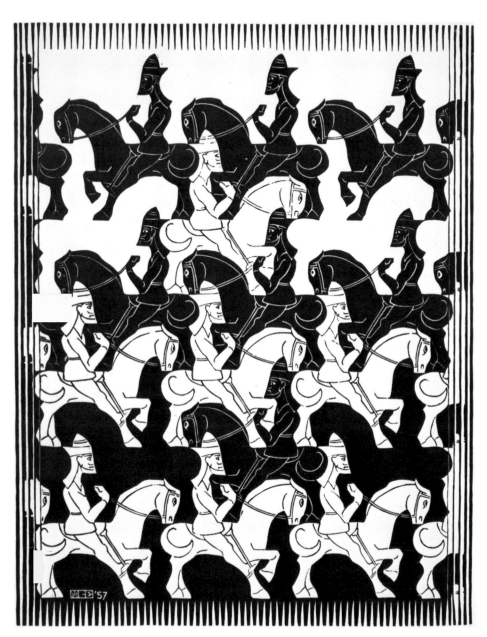

*Regular Division of the Plane III*

*Regular Division of the Plane IV*

vertically placed plane of representation. The horsemen of woodcut III and the dogs of IV are very definitely less suitable for floor or ceiling than for wall decoration because the concepts "above" and "below," with which their representation is very closely connected, are not interchangeable. Thus we can say in general that glide-reflection motifs are suitable for walls, and axis motifs for floors and ceilings, while translation figures can serve for both.

In a more general sense, and not only with specific reference to regular division of planes, it is because of the vertical posture of the human body that walls of rooms, more than floors and ceilings, are provided with representations and decorations. After all, we look at the horizon more often and with less effort for our neck muscles than we look up or down. Only when lying stretched out on the earth's plane are our eyes directed naturally toward the heavens. Thus it is understandable that plastic artists since time immemorial have shown a distinct preference for subjects with a horizon, whether visible or not, and usually make representations that are meant to be seen on a vertical plane.

While pondering these things, I am reminded of the guided tours through the Sistine Chapel, which I took several times under the guidance of experts while living in Rome. No matter how fascinating Michelangelo's ceiling paintings are, uppermost in my memory is the fatigue of gazing up while in a standing position. Less sublime, but easier and more pleasant to observe, was the spectacle before my eyes when I was reclining in the chair of my Roman barber, who had set up his shop in one of the rooms of an old building. I often remember with sadness and longing those scrolls, flourishes, and little pink angels when I observe, leaning back in the chair of my present Dutch barber, nothing but a bare, undecorated ceiling.

Just as I started the series of prints in woodcut I with a story in images, so I will end in *Regular Division of the Plane VI* (page 117) with another example that can be considered a dynamic action. Here it is not a matter of a process of development in contrast and form but of something we might call "halving" or "doubling," "reduction" or "enlargement," "division" or "multiplication," depending on whether the print is observed from top to bottom or from bottom to top. Whatever name we use, it is a fact that "something is happening," and that it happens in a vertical direction. Also, two extreme limits can clearly be distinguished. At the top the plane is bound by the "singularity" of only one animal, with a reptile form, arching like a roof over the entire width of the print. At the bottom the representation is closed off in a horizontal-rectilinear way by a "multiplicity," a theoretically infinite number of infinitely small animal figures.

In *Figure 3*, page 116, this process is reproduced schematically. The animal forms are here simplified to their original primitive shape of right-angled isosceles triangles. The limit of infinite reduction is reached in the base line r–s.

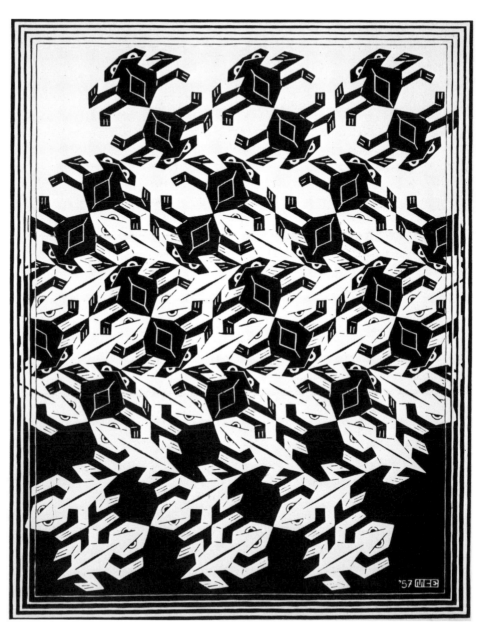

*Regular Division of the Plane V*

The course from top to bottom now takes place as follows. The triangles 0, A1, and B1 together form a square whose line p-q is a diagonal. The surface of A1 is equal to that of B1, and together they are equal to that of 0. But A1, C1, and E1 together also form a square; C1 and E1 are thus each half of A1. From this it follows that the surfaces continuously halve themselves, that is, $0 = 2 \times A1 = 4 \times E1 = 8 \times A2 = 16 \times E2 = 32 \times A3$, etc., into infinity.

If one looks at it superficially, all the reptiles of woodcut VI appear to have the same form. But in reality the plane is constructed out of six different figures, none of which have the same form, nor are they congruent with each other. However, they form a group of six, or a block, which as a unit does repeat itself in the same form. If we again mentally substitute the triangles of the figure with the corresponding animal forms, then we see such a block of six defined by p-q-t-u. It repeats itself in the same form and is four times reduced in the rectangle t-v-w-x. All the separate reptile figures that are indicated with the same capital letter consequently have the same form, for example, E1, E2, E3, etc. However, E1 and F1, for example, do not have the same form. Since we are dealing here with a system of plane division in which each time three figures touch one another at one point, the two contrasting shades, white and black, are not sufficient in number. A third shade should have been used in order to separate all the figures logically from one another. This has been omitted on purpose. The only third shade I could have applied is gray, that is, hatched black. However, gray has a very definite function as background color in this woodcut. As white and black stains become smaller and smaller, approach one another ever more closely, and become theoretically infinitely small, the automatic result is ideal gray, which was extensively discussed in the beginning of this composition. That is why not only the border around this woodcut has the color gray, as do all the other prints, but also, and especially in the margins of the woodcut itself, an attempt has been made to approach the ideal gray, which results from black and white flowing into each other. Woodcut VI is thus the only example in this book in which the plane division makes it desirable to have more than two contrasting shades. A complete survey of the possibilities of regular plane filling would contain a good twenty illustrations in three colors, in addition to white and black. I have designed numerous fillings with a rhythmic repetition of two different shapes, such as the one shown in woodcut V, and even of three or more dissimilar shapes, for which at least three and sometimes four colors are advisable. As the three different motifs are equivalent, three colors of equal value must be used. White, gray, and black are unsuitable because they are not of equal value; instead they form a series and express an increasing intensity.

The fact that I limit myself to white and black within this scope is a personal preference and in complete agreement with my inclination toward a dualistic outlook on life. I hardly know the enjoyment of the free painter who uses colors for the sake of

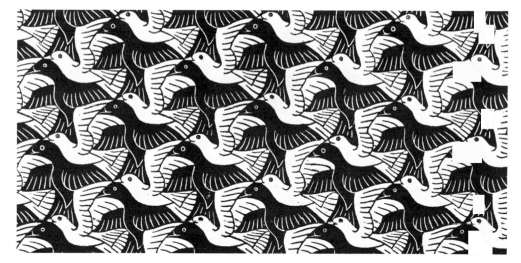

*Design Fragment*

the colors themselves. I apply them only when the nature of my shapes makes it necessary. Only when my motifs are more than binary am I forced to use them.

In the images discussed, the concept of infinity, an attribute of regular division of planes, never becomes a logically enclosed whole. This does not happen even in the last woodcut, which, after all, allows for unlimited expansion toward left and right. However, the desire for enclosure and limitation is actually one of the incentives that stimulated me to make many closed compositions inspired by the division of planes. I regret that it is impossible, owing to the nature of this publication, to include reproductions of these works of art.

This notwithstanding, I want to say something about the principal ideas that I tried to express in them. These can be divided into five categories:

## 1. TWO-DIMENSIONALITY

It is all a matter of the extent to which we are aware of the space, the miracle, that we call "reality." Our entire nature is so closely linked to the concept of three-dimensionality that it is just as impossible to imagine two dimensions as it is four. Something that is completely flat does not exist for us any more than something that is more than volumetric. When an element of plane division suggests to me the shape of an animal, I immediately think of a volume. The "flat stain" irritates me. It's as if I were shouting to my objects, "You are too fictitious for me; you just lie there immovable and tightly fitted

*Figure 3*

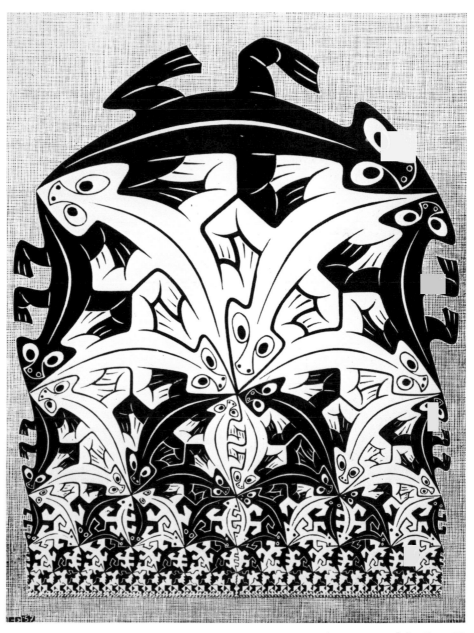

*Regular Division of the Plane VI*

together; do something, come out of there, show me what you are capable of!"

So I allow them to step out of the plane. Do they really do it? No, I am knowingly inconsistent. By indicating the effect of light and shadow, I suggest plasticity on the plane. And by doing this, I arrive on dangerous ground, on quicksand, where I prefer not to penetrate too far. Words, at least my words, are inadequate for approaching it. Images can do it better.

My objects, fictitiously brought to life, can now make their own way as independent plastic beings. If they want to, for example, they can eventually return to the plane from which they stepped forth in the beginning and disappear. Such a cycle then constitutes a self-contained subject for a print. If the plane filling, which served as point of departure, consists of a repetition of two motifs that are different in form and character, they can express their possible aggressive antagonism by destroying each other. Or, if a peaceful solution is chosen, they can become reconciled with each other in a fraternal embrace. All kinds of variations on this theme are possible, and I have, in fact, not been able to resist the temptation to use a different solution every time.

## 2. THE CURVED SURFACE

Instead of leaving the plane only mentally, as was described above, we can also do this in reality. I don't mean that the figures should completely step out of the plane as separate individuals by modeling them in clay, for example, because then the result would be a dual nature, half flat and half spatial. No, I am here considering the possibility of bending and curving the image plane itself. Why wouldn't the surface of some object or other—a cylinder, a cone, an egg, or a sphere—lend itself to rhythmical division just as well as a plane? And indeed this turned out to be the case when I tried it. The surface of a sphere, for example, can be divided into 2, 4, 6, 8, 12, 20, 24, and more equivalent and similar sphere triangles, in part congruent and in part one another's mirror image. Such a sphere, covered with a specific and limited number of recurring motifs, is as an object in its own right a splendid symbol of infinity in an enclosed form. When we hold it in our hands and slowly let it revolve, the figures that have been placed on it line up one after the other in an infinite series, and still they are always the same ones that repeat themselves. I designed and executed several in wood on which the motifs were portrayed in bas-relief. Contrasting effects were obtained by staining in two or more shades.

However, such a foray into space remains an exceptional activity for one who is not a sculptor. An illustrator can rarely allow himself such a side trip into reality, and he happily returns to his flat representation of images. After all, he feels more at home with his fictitious suggestions, and anyhow they offer him a more extensive field in which to live out his fantasies. If the graphic artist wanted to, however, he could make

use of a cylindrical surface without thereby renouncing his profession. He could take the paper on which he has made the copy and bend it into the shape of a tube so that the top and bottom sides — or the right and left sides — of his representation coincide with each other. In the direction of the body axis of his cylinder, his division of a plane remains, however, still arbitrarily bound. He can never fashion his paper into a sphere without folds or wrinkles.

## 3. THE DYNAMIC BALANCE AMONG THE MOTIFS THEMSELVES

This most fascinating aspect of division of planes, which has already been discussed, has led to the creation of numerous prints. One feels here the urge to represent all kinds of opposites. Isn't it, in fact, obvious to arrive at a theme such as "Day and Night" as a result of the double function possessed by both the white and the black motifs? It is night when the white as object stands out against the black as background. It is day when the black figures stand out against the white as background. Also the concept of a duality such as "Sky and Water" can be manifested as image by taking as point of departure a plane filling built up out of birds and fishes. The birds are water with respect to the fishes, and the fishes are sky with regard to the birds. Heaven and hell may be symbolized in a similar way by an interplay of angels and devils. Many other "units of opposites" come to mind, at least theoretically, since in most cases their realization is hindered by insurmountable difficulties.

## 4. THE IMAGE STORY, THE ACTION

In addition to the above discussion, the dynamic character of regular division of planes has been extensively covered in the description of woodcuts I and VI. With regard to the latter, I once wanted to execute a similar process, gradually decreasing the size of the elements to the farthest possible limit. I did this in a woodcut in which that limit was located in the center, thus in one point and not on a line as in woodcut VI. I used a small block of palm wood of the very best quality available. On this I engraved ever smaller animal figures, starting at the edges and working toward the center. As I approached the middle, ever higher demands were made on the sureness of my hand, the keenness of my sight, the sharpness of my engraving iron, and the quality of my material. By the time my small image surface had been reduced to a square centimeter, I needed a set of three magnifying glasses placed on top of one another in order to see clearly enough what I was doing. The smallest figure still recognizable as a complete animal shape, with head, tail, and four legs, had a total length of about two millimeters. During this extremely minute work — minute for me at least, but what is our Western skill compared with the proficiency of the Eastern artisan? — I experienced once again

that the human hand is capable of executing very small and still completely controlled movements, on the condition that the eye sees sufficiently clearly what the hand is doing. When the hand becomes unstable, this is almost always the result of inadequate sight. When we think we have reached the limit of our "handiness," it becomes apparent that we still possess it in more than sufficient measure if we use a stronger magnifying lens.

I have also made many representations of development processes in form and intensity of contrast, such as that in woodcut I. This can be done in the form of a band or an open or closed ring, and it can be done directed toward a center or radiating outward. One can even make it into a story of creation. Out of a nebulous gray indeterminateness, primeval shapes can loom up that develop into animal figures in gradually more contrasting shades. In the final stage of their development these creatures of land, water, and sky stand out against the background of the element in which they live. I made such a print once years ago.

## 5. METAMORPHOSIS, TRANSFER FROM ONE FORM TO ANOTHER

Such changes of shape in the motifs are difficult to describe in words. That's why I give an example of them in *Figure 4*. It shows, at a greatly reduced scale, a fragment of a series of metamorphoses. They are associations of images and thoughts that I combined in a woodcut, printed from sixteen different blocks onto a strip of paper four meters in length. The fragment reproduced here shows one change of shape, from "insect" to "bird," going from left to right. At first the black insect silhouettes approach one another. At the point where they touch, their white background has become fish-shaped. By interchanging figures and background, white fishes are subsequently swimming against a black background. The fishes thus function more or less as catalysts. Their form changes hardly at all, but their posture with respect to one another does change; their "battle array" is modified. When they are reunited, their interspaces appear to have become bird-shaped.

Once again it has become apparent from *Figure 4* that a dynamic character is obtained by a succession of figures in which changes of form appear gradually. We have repeatedly pointed out the difference between a series of film images projected cinematographically and the series of figures of a regular plane division, which are portrayed in finished form next to one another on a strip of paper. Still the element of the passage of time appears in both.

Here I want to venture even somewhat further and be so bold as to observe comparisons, maybe even points of agreement, between the regular division of planes and music. I do not suggest that these are equivalent in scope because music in its entirety should be seen as equivalent to the entire range of the visual arts. Of these,

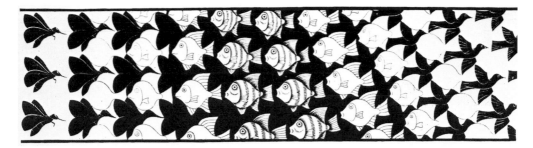

*Figure 4*

regular plane filling is an extremely small part if it manifests itself in an artistic way at least. One can also accept it as an objective concept, separate from all thoughts of art.

Before going on to enumerate resemblances (or what I judge to be such), I must ask myself, "Is it really possible to compare the visual image with the audible sound?" I postulate that I am aware of the difference in their natures. Music is present only while we hear it, from its beginning to its end, and not before nor after. On the other hand, an observable series of images, immovable on its own account, does not have to be re-created again and again once it has been made. I also know that the arts can be divided into two groups: on the one side those bound to a specific passage of time, such as music, theater, film, and dance, and on the other the static products of the visual arts, including architecture.

Despite these differences and contrasting natures, I can conceive of the series of images of a plane division and the sequence of sounds of a musical composition as different steps of just one staircase. By way of a number of steps in between, we can connect them with each other in the following manner. First step: purely looking at or observing the visual images represented next to each other on a plane. Second step: reading or soundlessly interpreting the letter symbols placed next to each other. Third step: reading aloud letters, words, and sentences that are strung together, whereby now for the first time vibrations of sound are produced. Fourth step: singing of those words, the creation of a song. Fifth step: singing only a melody, even without words. Sixth step: playing music in general, by means of whatever instruments.

And now the specific points of agreement that I have observed. They are expressed with the greatest possible reservation, and I leave it open to judgment as to whether they are objectively acceptable.

Just as music has various kinds of rhythmic intervals that are indicated by numbers—the second, third, fourth, and sixth quarter measures—so can the division of a plane be

built up in accordance with binary, ternary, quaternary, and sesternary axes that each represent a specific way of rhythmic repetition of the motifs on the plane.

It seems to me an undeniable fact that the fifth quarter measure is less easily discernible by the ear of the average music lover than other kinds of measures, some of which I mentioned earlier. I understand that it wasn't used until after the beginning of the nineteenth century, and since then only sporadically compared with the tried-and-true measures. It would be going too far if we saw in this fact a direct analogy to the lack of a quinary axis on the plane, which is possible only on a spherical surface. Anyhow, I find it worth mentioning as a curiosity.

General elements such as rhythm and repetition, which play an important part for the auditory sense in music and for the visual sense in plane division, also indicate a certain affinity between the two. I have often noticed that, in addition to being demonstrated in the static result of figures on a plane, the process of marking off rhythmic intervals with measures also reveals itself at an earlier stage. This happens during the act of drawing on paper or engraving in wood, when the hand executes movements that repeat themselves rhythmically as in a dance. And during this process the person experiences an urge to emphasize the beats with his voice or to sing while working.

If we consider this in more detail, it turns out that the musical canon includes concepts such as enlargement, reduction, reversal, and even reflection, and that these are indicated visually in the score in a way that is directly comparable and in agreement with the figures of a regular plane filling.

Let me end this composition with a testimonial to the influence of Bach's music on my work. His reasonableness, his mathematical arrangement, and the severity of his rules probably play an important role, but not a direct one. It is an influence based on feelings that takes place, at least as far as my conscious perceptions while hearing his music are concerned. Still, or maybe because of this, the stream of his sounds works in a way that fertilizes and inspires. It happens both in the sense of calling forth specific inspirations or images, as well as promoting in general an irresistible urge to make images. In his music, more than in any other classical or modern music, something self-evident is revealed to me. It is something I was expecting without having been aware that I was, the way one occasionally recognizes a landscape one is seeing for the first time. A vague feeling of expectation and suddenly emerging hope sometimes manifests itself during a concert, in the middle of a period of sterility. Longing for creativity precedes the urge to create itself, and this is the first spark that sets in motion the mechanism of making images. Thus my periods of slackening, mental emptiness, and listlessness call for the music of Bach as a tonic to stimulate my longing for creativity.

# APPROACHES TO INFINITY

Human beings can't imagine that the stream of time could ever come to a halt. It seems to us that time will continue to flow on eternally, even though the earth will cease to revolve around its axis and the sun, even though there will then be no days and no nights, no summers and no winters.

Neither can we conceive that somewhere behind the farthest stars in the night sky there exists the end of space and a boundary behind which there is "nothing." The concept "empty" still means something to us because a space can be empty, at least in our thinking. However, our imagination is inaccessible to the idea of "nothing" in the sense of "spaceless." That is why we clutch at a chimera, an afterlife, a purgatory, a heaven, a hell, a rebirth, or a nirvana, all of which would then be eternal in time and endless in space. We have been doing this ever since human beings have been lying, sitting, and standing on this terrestrial globe, ever since they have been crawling and walking on it, sailing, driving, and flying over it (and will soon fly away from it).

Has any musician, any artist for whom time is the canvas on which he embroiders, ever felt a longing well up inside to approach eternity in sounds? I don't know. If, however, the answer is "yes," then it seems to me that the means at his disposal are inadequate to satisfy that longing. How could a composer succeed in evoking the suggestion of something that does not end? Music is not there, neither before it begins nor after it ends. It is present while our ears receive the sound vibrations of which it consists, neither before nor after. A stream of melodious sounds that continues without interruption for an entire day does not produce a suggestion of eternity, but of fatigue and boredom. No avid radio listener ever received any notion of eternity by leaving it turned on from early morning until late at night, even if he chose only sublime classical programs.

No, this problem is even more difficult to solve for an artist practicing the dynamic arts than for a practitioner of the static arts. The latter may want to penetrate all the way into the deepest infinity right on the plane of a simple piece of drawing paper by means of immovable and visually observable images. It is doubtful if there are many

present-day plastic artists, including illustrators, graphic designers, painters, sculptors, who experience such a longing. In our time, artists who make representations are instead driven by impulses they cannot, and do not want to, describe. They are driven by an urge that is not intellectual, but unconscious or subconscious, an urge that words cannot describe.

However, it may happen that someday someone will feel a specific and conscious longing ripening within him to approach infinity as purely and as closely as possible by means of his representations. This may happen to someone who has not absorbed much factual knowledge—someone who has not done much studying of previous generations, someone who, as plastic artists do, fills his days with the designing of more or less fantastic images.

Deep, deep infinity! Rest, dreaming removed from the nervous tensions of daily life; sailing over a calm sea, on the bow of a ship, toward a horizon that always recedes; staring at the waves that go by and listening to their monotonous, soft murmuring; dreaming away toward unconsciousness. . . .

When one dives into endlessness, in both time and space, farther and farther without stopping, one needs fixed points or milestones past which one speeds. Without these, one's movement does not differ from standing still. There must be stars along which one shoots, beacons from which one can measure the road covered.

He must divide his universe in distances of a specific length, in compartments that repeat themselves in endless series. At every border crossing between one compartment and the next, his clock ticks. Whoever wants to create for himself a universe in a two-dimensional plane will notice that time goes by while he is working on his creation. (He is kidding himself, because in our three-dimensional world neither a reality of two dimensions nor a reality of four can exist.) When he is finished, however, and looks at what he has done, then he sees something that is static and timeless. In his representation, no clock ticks. Only a flat, motionless expanse is revealed. Nobody can draw a line that is not a border line. Every line splits a unity into a multiplicity. Whatever its form may be, whether pure circle or capricious stain with haphazard form, every closed outline also calls forth the concepts of "inside" and "outside." Subsequently these are soon followed by the suggestion of "nearby" and "far off," that is, object and background.

The dynamic, regular ticking of the clock at every border crossing of our trip through space is silenced. However, we can replace it, statically, with the periodic repetition of similar figures on our drawing plane. We will draw enclosed forms that border one another, determine one another's shape, and fill up the plane toward all sides as far as we want.

What kind of figures? Capricious, formless stains that do not call forth in us any associative thoughts? Or abstract, geometrical, rectilinear figures, squares or hex-

agons, which at most remind us of a chessboard or a honeycomb? No, we aren't blind, deaf, and dumb. We consciously observe the forms that surround us and in their great variety speak a clear and fascinating language to us. That's why the forms we use to compose our plane division must be recognizable as tokens and clear symbols of the living or dead matter around us. When we make a universe, let it not be an abstract one, not a vagueness, but a concrete representation of recognizable objects. Let us build a two-dimensional universe from an infinitely large number of similar, but clearly recognizable building blocks.

It can become a universe of stones, stars, plants, animals, or people.

What has been accomplished in terms of the regular division of planes in *Symmetry Work 25* (page 47)? Not yet an infinity but already a fragment thereof, a piece of "the universe of reptiles." If only the plane on which they follow one another were infinitely large, an infinitely large number could be represented on it. However, we aren't playing a game of imaginings. We are conscious of living in a material, three-dimensional reality, and we cannot possibly manufacture a plane that stretches out infinitely far toward all sides. We can, of course, curve the piece of paper on which this world of reptiles is represented as a fragment. We can make a paper tube of it in such a way that the animal figures on that cylinder surface continue to follow one another without interruptions while the tube revolves around its lengthwise axis. In this way, infinity is achieved in one direction, but not yet toward all sides because we can no more manufacture an infinitely long tube than we can manufacture an infinitely expanding plane.

*Carved Beechwood Ball with Fish* (page 37) gives a more satisfying solution: a wooden ball whose surface is completely filled by twelve congruent fish shapes. When we turn the ball around in our hands, we see fish after fish appear, continuing into infinity.

Is this spherical result, however, really completely satisfying? Certainly not for a graphic artist, who is more bound to the *flat* plane than an illustrator, painter, or sculptor is. In addition, and leaving that aside, twelve similar fishes are something different from infinitely many.

There are, however, other possibilities for representing the infinite number graphically without curving the plane. *Smaller and Smaller* (page 41) is a first attempt in that direction. The figures out of which the image is composed are steadily reduced to half their size in surface area, radiating from the edges toward the center. There the limit of the infinitely many and the infinitely small is reached in one point. However, this composition also remains a fragment because we can expand it as far as we want by adding ever larger figures. The only way to escape the fragmentary character of the composition and to contain an "infinity" in its entirety within a logical border line is to work at it in reverse order from the way it was done in *Smaller and Smaller. Circle Limit I* (page 126) gives a first and still awkward application of this method. The largest

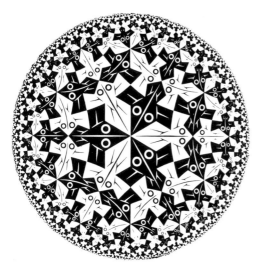

*Circle Limit I*

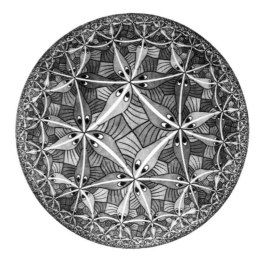

*Circle Limit III*

animal figures are now located in the center, and the limit of the infinitely many and the infinitely small is reached at the circular edge. The skeleton of this composition, except for the three straight lines that pass through the center, consists only of circle arcs with radii that get ever shorter the closer they approach the edge that forms the limit. Furthermore, they all intersect the edge at right angles.

This woodcut, *Circle Limit I*, being the first of its kind, reveals various shortcomings. Both the form of the fishes, who have barely grown from rectilinear abstractions to rudimentary animals, and their placement with respect to one another leave something to be desired. One does recognize series, accentuated by their body axes following one behind the other. However, they consist of white pairs with their heads turned to each other, alternating with black pairs whose tails touch each other. There is thus no continuity, no "direction of the flow of traffic," no unity of color in each of the rows.

In the color woodcut *Circle Limit III* (page 43 and above right), the defects listed above have for the most part been corrected. There are now only series "with through traffic" remaining. All the fishes of the same series also have the same color and follow one another, swimming head to tail along a circular course from edge to edge. The closer they approach the center, the larger they become. Four colors are needed so that each row in its entirety contrasts with the surroundings. All these series arise at a ninety-degree angle from infinitely far away, like rockets out of the limit, and again lose themselves there. Not a single component of these series ever reaches the boundary line. Outside of it, however, is "absolute nothingness." Yet the round world cannot exist

without that emptiness around it. Not only because "inside" presupposes "outside," but also because in the "nothingness" are located the immaterial and rigidly geometrically ordered centers of the circle arcs out of which the skeleton is built up.

There is something breathtaking in such laws. They are not inventions or creations of the human mind, but "are" or "exist" independently of us. During a moment of clarity one can at the most discover their existence and become aware of them. Let me give a more tangible example than this flat disk. Long before there were people on earth, crystals grew in the earth's crust. One day a human being saw for the first time such a glimmering little piece of regularity lying about, or he hit it with his stone pickax, and it broke off and fell in front of his feet and he picked it up and looked at it in his open hand and he was amazed.

# PERSPECTIVE

To begin, I would like to ask myself, and you, the meaning of the concept "perspective." (The word stems from the Latin verb *perspicere*, that is, to look through something.)

If we sit in a room in front of a window, not too far away so that we can just touch it with an outstretched arm, and if we then hold our head as motionless as possible, we can draw or trace on the windowpane (for example, with a pointed piece of soap) the landscape or cityscape that we see through the window.

The result is a representation in perspective, a projection of spatial forms on the plane of the glass.

If there are straight parallel lines in the landscape before us, it becomes evident that in making our drawing on the window the directions of those lines comply with specific rules. From those rules, apprehended by experiment, we have constructed the theory of perspective. This theory is thus most closely connected with the presence of *straight parallel* lines in the space around us.

It is striking to note how few *straight* lines, parallel or not, appear in a landscape not yet touched by human hands. A wild and hilly view, for example, generally contains only capricious and curved lines except for the straight vertical trunks of a forest of fir trees. If we disregard the trunks of some types of trees that can be straight as arrows and the horizontal lines of some cloud formations, there remain in all of untouched nature only a few truly straight lines that are sufficiently extended to enable us to observe perspective in them. However, as soon as human beings start meddling with virginal nature, it immediately teems with straight and parallel lines and planes.

Perspective is thus a typically human concern. This is so not only because an animal lacks the necessary intelligence, as far as we know, to discern such a law as that of perspective. Another reason is that the insight into that law became possible only after man started correcting nature in accordance with his own human needs.

As soon as man builds himself a dwelling, a second interesting phenomenon appears. Not only does he surround himself with a complicated network of innumerable straight and parallel lines but he usually restricts himself to just two directions for those lines. Out of the infinite variety of directions at his disposal, he chooses almost exclusively the vertical and the horizontal!

What exemplary obedience is manifest in that restriction, but also what pitiful slaves we apparently are to the power of gravity that dominates everything on earth! And then that straight angle between horizontal and vertical! Almost everything that we build and manufacture—houses, rooms, closets, tables, chairs, beds, books—all these are in principle rectangular boxes. How terribly dull and boring they really are, those walls of our rooms always and ever with the same ninety-degree angles. And what we hang on those walls are again rectangular frames with rectangular prints inside. And when we look through the window, we look again through a rectangular hole in the rectangular wall.

Our only consolation is that we can't help it. It isn't our fault. Whether we like it or not, we must obey our tyrant, gravity. But that dictator, against whose will we oppose ourselves in vain, is at the same time perhaps the most perplexing and moving miracle of all of creation. No matter how strongly I am aware of this and how speechless with admiration I observe the natural phenomena in which gravity manifests itself, I still can't help being sometimes inexpressibly bored with the rectangularity of our walls and the cubic or parallelepiped principle that is the basis of our structures. Perhaps you are of the opinion that it would become a lawless and chaotic world if we could ban the rectangle and the parallelepiped from our society. I don't agree with you because the cube is but one of the five regular solids that we know, and the other four are just as much paragons of the highest order and rhythm. This was already known to Albrecht Dürer and Luca Pacioli.

What splendid buildings our architects would be able to execute if only they could finally be less obedient to gravity! Just imagine a tetrahedral streetcar shelter, or an octahedral factory, or a dodecahedral church (dedicated to the twelve apostles, for example), and dwellings with triangular windows and pentagonal walls and floors. Speaking of perspective: what rich perspectives would open up for furniture makers and book printers; hexagonal bookcases with triangular books inside!

But I must stay with my subject and keep to the vertical and parallel horizontal lines and planes without which we can't function. In fact, those horizontal and vertical qualities are fascinating enough for an illustrator, even if deep within himself he longs for unreachable other systems.

First of all, I have to remind you of a very simple example of perspective.

When you cross a straight set of railroad tracks in a flat landscape and stop midway between the two pairs of rails and look in the direction of the tracks, you will see this:

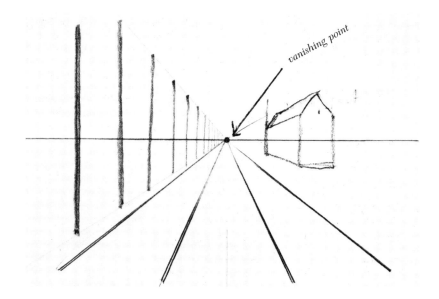

We see in this sketch two sets of parallel lines. First the horizontal lines of the rails and second the vertical lines of the telegraph poles. In actual space the rails run parallel to each other, just as the telegraph poles run parallel to each other. The curious thing here is that in our drawing the vertical lines *remain* nicely parallel to each other, while we see that the horizontal ones intersect each other at a point on the horizon. In the system of perspective this is called the *vanishing point*. It is the main principle of the old theory that, if I remember correctly, was first set forth by Italian painters and architects at the beginning of the Renaissance. That basic principle was worded approximately as follows:

All lines that stand in a vertical position in real space also remain vertical when drawn on a plane. However, *almost* all horizontal lines that in real space run parallel with each other intersect one another on the plane of our drawing at a point that is situated on the horizon. (There is one exception to this rule, which is for lines that run parallel to the horizon. These keep their parallel character also in our drawing.)

This is a beautiful rule, but it is not altogether correct.

To my knowledge, no painter or illustrator ever deviated from this rule during the Renaissance. Even now, as far as I know, architects always follow it in their sketches. They must have well-founded reasons, yet they know, just as surely as I do and maybe even better, that the rule does not hold up very satisfactorily.

Until recently there was also little occasion to notice the mistake. However, since the invention of photography, since we began building very high structures, skyscrapers, and since man has been able to ascend above the surface of the earth and observe things from an airplane, it is clear that something is amiss in that old theory.

Rather than using skyscrapers, I think it would be nicer to try demonstrating that flaw, using a building that existed before the rules of perspective were determined during the Renaissance. The interiors of certain tall Gothic cathedrals lend themselves perfectly for this demonstration, particularly, as I recall, Cologne Cathedral.

In that church the nave is separated from the choir by two enormously high half-pillars. Not a single protruding ornament interrupts the vertical character of these pillars along their great height. The relatively wide passage between the two columns seems narrow in relation to their enormous height. When we stand in the nave, as far away as possible from that high and narrow portal, we could with a little effort still portray these two tall verticals as parallel lines, as here:

Now we walk slowly along the center aisle toward the portal in the distance while continuing to keep our eyes directed at its upper part, so that gradually we have to bend our heads farther back and thus look upward at an ever increasing angle.

We now see how it happens that the verticals do not continue to remain parallel, as they should according to the rule, but start forming an ever more obtuse angle the closer we approach. They appear to intersect each other at the point directly above our heads. In that zenith is thus located a vanishing point for verticals.

A second vanishing point for vertical lines, in the *nadir*, is located at a perpendicular under our feet. In order to make that clear we will go to modern times and imagine that we are looking down from a window on the twentieth floor of a skyscraper. We are in a corner room, and far below us we look down at the crossing of two streets. Now the many perpendicular lines of the ribs of the skyscraper intersect one another at the nadir vanishing point. We also see that the *horizontal* lines of the streets and sidewalks continue to run parallel to one another in our drawing and that they consequently do not appear to keep in any way to the old rules of perspective.

However, there is still another matter. Assume that, while looking out of our window on the twentieth floor, we have across from us a forty-story building. We now get the idea of making a drawing of that *entire* skyscraper, from bottom to top.

When we look down, we see the street and the base of the building. Looking straight up, we see the edge of the flat roof. How can we *portray statically* on the plane of the paper such a *dynamic, cinematographic image* whereby our eyes go across 180 degrees from zenith to nadir? Let's first do it in three stages.

First: looking *down*. We now get an image that looks a lot like what we drew earlier.

Second: looking toward the *horizon*. This is at the height of the twentieth floor across from us. The perpendicular lines now actually run as verticals on our paper.

Third: looking straight *up*, toward the edge of the roof. We now see the verticals converging again toward the zenith vanishing point.

In order to make one continuous representation out of these three separate images, we draw curved lines from zenith to nadir that touch the corresponding lines of the three stages. We really should draw such a representation on the concave side of a cylindrically curved piece of paper. Without any problem we can straighten out the paper again, and then we see, a little more stretched out, the same image on a plane.

We can just as well do something similar with horizontal lines, for example, with the railroad tracks used earlier. We imagine that we are standing on a narrow railroad crossing, on a bridge for pedestrians five meters above the tracks.

Here, too, we again make our drawing in three stages:

First: looking toward the *horizon*. Now we get a repeat of our first sketch (page 130).

Second: looking *straight down* over the railing of the bridge. Below us we see the four rails parallel to one another.

Third: we remain with our feet in the first position, but bend very far forward and look between our legs in the *direction of the horizon across from us*. We then see a landscape on its head, and we thus draw it on its head.

Just as earlier with the skyscraper, at the two horizons we connect the two vanishing points with curved lines that touch our earlier lines of the three stages.

And the telegraph poles, what happens to them? Like good verticals, they run curved from zenith to nadir, as we saw earlier.

So you see: there are only a few straight lines in a spatial image that should also remain straight in a drawing. Everything becomes unsettled.

# THE IMPOSSIBLE

It sometimes seems to me that we are all afflicted with an urge and possessed by a longing for the impossible. The reality around us, the three-dimensional world surrounding us, is too common, too dull, too ordinary for us. We hanker after the unnatural or supernatural, that which does not exist, a miracle.

As if that everyday reality isn't enigmatic enough! In fact, it can happen to every one of us that suddenly, with ecstasy in our hearts, we feel the rut of daily life fall away from us for a moment. It can happen that we become receptive to the unexplainable, to the miracle that surrounds us continuously. It is the miracle of that same three-dimensional spatiality in which we trudge along daily, as on a treadmill. That concept of spatiality reveals itself sometimes, in rare moments of lucidity, as something breathtaking.

It has happened to me during lonely walks through the woods around Baarn that I suddenly stopped dead in my tracks, seized by an alarming, unreal, and at the same time blissful feeling of standing eye to eye with the unexplainable. That tree there in front of me is of its own as object, as part of the woods, maybe not astonishing. The *distance*, the *space*, between it and me, however, seems suddenly enigmatic.

We do not know space. We do not see it, we do not hear it, we do not feel it. We are standing in the middle of it, we ourselves are part of it, but we know *nothing* about it. I can measure the distance between that tree and myself, but when I say, "three meters," that number reveals nothing of the mystery. I see only boundaries, markings; I do not see space itself. The prickling on my skin caused by the wind blowing about my head is not space. When I feel an object with my hands, it is not the spatial object itself. Space remains inscrutable, a miracle.

So the reality around us should already be unexplainable and mysterious enough! But no, we are not satisfied with it and persist in playing with stories and images in order to escape it. As children, and also some of us still as we get older, we read fairy tales. Later on we read in the Bible, whether or not with belief, about the staff of Moses that turned into a snake, about the burning bush, the mysterious multiplication of loaves, and the changing of water into wine. Not to mention the stories of even greater miracles.

Whoever wants to *portray* something that does *not* exist has to obey certain rules. Those rules are more or less the same as for the teller of fairy tales: he has to apply the function of contrasts; he has to cause a shock.

The element of mystery to which he wants to call attention must be surrounded and veiled by perfectly ordinary everyday self-evidences that are recognizable to every-one. That environment, which is true to nature and acceptable to every superficial observer, is indispensable for causing the desired shock.

That is also why such a game can be played and understood only by those who are prepared to penetrate the surface, those who agree to use their brains, just as in the solving of a riddle. It is thus not a matter for the senses, but rather a cerebral matter. Profundity is not at all necessary, but a kind of humor and self-mockery is a must, at least for the person who makes the representations.

# 4

A SUBJECTIVE PORTRAIT

As the conclusion of this selection from the writings of Maurits C. Escher there follows, under a title borrowed from Escher's own words, a portrait of the graphic artist written by Jan W. Vermeulen, who came to know Escher personally when the author had already passed middle age. It turned into a subjective portrait, based on an ever greater involvement in the life and work of the already somewhat elderly artist and an increasingly strong relationship, which continued until Escher's death on March 27, 1972.

# I'M WALKING AROUND ALL BY MYSELF HERE

By J. W. Vermeulen

After having worked as a graphic artist for decades, Maurits Escher still was unable to achieve any renown outside of a small circle

There were, of course, a few of his fellow graphic artists who followed his work with respect, but that respect was more concerned with the craft rather than the content of his work.

Also among the general public interested in art only a few were familiar with Escher's name and could muster appreciation for the type of endeavor in which he was engaged.

During the thirties G. J. Hoogewerff was one of the first art critics to recognize his greatness. In 1931 — Escher was thirty-three years old at the time — Hoogewerff had already mentioned his "indisputable mastery" and called attention to his work, which "in all its manifestations is characterized by deep reflection and true spiritualization." An appreciation and understanding of Escher's work, however, remained for a long time restricted to a small circle and an occasional word of praise. Too little for an independent artistic career. If it hadn't been for his well-to-do parents and parents-in-law, he would have had to live in real poverty all those years or perish without fame in some routine little job or other.

Then, all of a sudden, the breakthrough. In 1951 articles about Escher appear in leading American journals. In 1954 there is the large exhibition of his work at the Stedelijk Museum in Amsterdam, which is hugely popular. After this, public interest knows no bounds. A true rage for Escher breaks loose, especially in the United States. In order to keep buyers from overwhelming him, Escher doubles his prices. He doubles them again. And again. It has no effect whatsoever; the demand for his work is undiminished. He is constantly busy making additional prints. Desperate, he complains that he has become a "stamping machine," that he has no time or energy left for creative activity. More and more his time and efforts are spent on selling, shipping, corresponding. Then there are the interviews, the lectures that he has to give, the exhibitions that have to be organized in various places. He is mobbed by fans,

besieged by art dealers. Articles have to be written, and the administrative activities are growing beyond his control. As a consequence of all this, he is under enormous pressure.

From one day to the next, the general public has jumped at his work as if completely familiar with that wayward form of art. Books by and about him, which formerly had appeared in modest printings, suddenly pass over the counters thousands at a time, then tens of thousands, hundreds of thousands. The same happens with reproductions of his prints. By the millions they are distributed throughout the entire world, in printings of such great numbers as had never before happened to a living artist.

Now the art critics are also expressing their admiration, with words such as "stirring," "fascinating," "incomparable beauty," "indelible impression," and others expressing similar sentiments. This definitely kindles the interest of art lovers, as well as that of scientists, especially mathematicians, crystallographers, physicists, and geologists; that of poets, writers, and musicians; that of all kinds of religious and social groups. Young people in particular must be mentioned here. Youngsters dedicate poems and write excited letters to him. A young man in London—a follower of the punk movement—has the print *Dragon* tattooed on his chest.

It seemed that everyone could find something of himself in Escher. Shouldn't he have been very satisfied with that? Both artistic and financial success were his, and it appeared that his needs for acknowledgment and understanding of his work were amply satisfied. An extremely mixed group of interested people had emerged, which left Escher utterly amazed, sometimes flattered, sometimes irritated, but always embarrassed by a public interest that was incomprehensible to him. He basked in it. Praise and appreciation, he found it all very pleasant, especially the attention and admiration of the scientific world, which he accepted with undisguised delight. The fact that the art critics remained at first still strongly divided about his work is to be expected. The artist who reaps only praise and no objections hasn't been born yet, and this applies even more to an artist like Escher, who was willful and unconcerned with the fashions of the time. During the last fifteen to twenty years of his life the critics who judged his work positively were by far the majority, and he often reaped extremely favorable reviews.

This notwithstanding, Escher sighed, "I'm walking around all by myself here."

This remark appears in his 1958 book about regular division of planes. Here he reveals how amazed he is by the fact that, as far as he knows, nobody shares his love for the "game" of dividing a plane into small recognizable figures that repeat themselves endlessly. This is a game of form and contraform with which he—to use his own words—is head over heels in love. It is painful for him to acknowledge the fact that

nobody can understand that love, let alone share it. He has the impression that he is the only stroller in the "splendid garden" of the regular division of planes, in that "pleasure ground" that refreshes him, but that is oppressive because of its emptiness.

It is true; he has indeed been alone in that garden for a time, while busy day and night, like a true pioneer, mapping and unlocking for others its beauty and treasures. However, he soon acquired companion strollers who came in order to be shown what he had found there.

Still he continued to feel lonely, and with the passing of the years this feeling became even stronger. He thought that the feelings and ideas on which his work was based were insufficiently recognized and valued at their true worth. For years he had suffered from the reproach that what he produced was too static, too cool, too dull, too cerebral, too insufficiently "artistic." Much too unapproachable. Not emotional enough. Increasingly he had the feeling that people understood nothing of his imagery. "What fascinates me and what I experience as beauty others evidently often judge to be dull and dry."

Now, with hindsight, we can establish that Escher was mistaken in this. Certainly before 1954 there were indeed many people who observed his "infatuation" either with a smirk or with compassion. Later on, however, more and more admirers appeared who, fascinated, accompanied him in his beloved garden and, just like him, pledged their hearts to it.

Despite the unexpectedly great success that overtook Escher late in life during the 1950s, as he got older he was plagued more and more often by the thought that he was a failure as an artist. All the doubts that had repeatedly assailed him—am I doing it right? is it turning into something? will it appeal to people? will people understand me? does it make sense to exert myself so much? why does nobody see what I see? why doesn't anybody find beauty in what touches me so deeply?—began to gnaw at him with increasing fierceness as he got older. Hadn't he, in fact, remained the failure that he was in his youth?

The child Maurits, called Mauk or Maukie. Sickly, shy, oversensitive, apparently far less talented than his much older brothers. Irresolute in character and with a deep aversion to school, where he was a fair to poor student, one who had to repeat classes and failed his final exam. Youngest child in a family with a highly critical mother and a strongly dominating father. A father who was conspicuous for his calm and levelheadedness, for his sense of simplicity, order, and regularity. A talented man also, a man who saw his family as a microcosm of harmony, intelligence, culture.[1] A father idealized by his youngest son, who thought that he compared very poorly to this Great Example and therefore was determined to do his utmost in order to show himself a worthy son in order to overcome and make up for the failures of his youth. As a

compensation, he forced himself to "exceed his supposed boundaries," as he wrote to his half-brother Johan George much later at the age of seventy-one. While the father had the habit of making notes about all kinds of matters, this took on almost compulsive form for the son. It is unimaginable what all he noted! He adopted his father's tendency toward exact thinking, his striving after order and simplicity. In his letter of April 26, 1950, to Oey Tjeng Sit, when he wants to clarify what has inspired him as a graphic artist, the nucleus of his argument can be rendered as follows: "Chaos is the beginning, simplicity is the end."

That's how he was. His entire life was marked by resistance to disorder. He feared and loathed it, but his fear and loathing were at the same time part of a love-hate relationship. Witness the following notation he made in his pocket calendar on December 4, 1958: "We adore chaos because we love to produce order." Thus chaos is the condition for producing order. They are two components of one reality, a reality that Escher above all wanted to see as a miracle of harmony. "I try in my prints to testify that we live in a beautiful and orderly world, and not in a formless chaos, as it sometimes seems," he says in 1965.[2] However, in January, 1967, he writes to Gerd Arntz, an artist and colleague, "The world in which we live is a hopeless case. I myself prefer to abide in abstractions that have nothing to do with reality." All his life he was aware of the experience of living in a beautiful, ordered cosmos, but at the same time suffering from the hopelessness of human reality. He saw a contradiction between, on the one hand, nature and the order on which it is based and, on the other, according to his feelings, the hopeless confusion of human society. The latter, the chaotic aspect of reality, threw him into disarray. In his attempts to portray this he had scant success. This is apparent, for example, in the prints he made in 1950 and 1955 relating to the opposition between order and chaos. The 1950 print is characterized by a particularly heavy symbolic, but somewhat awkward, rendering.

By nature insecure, sensitive, shy, the child Mauk grew into the young artist Maurits, who, despite everything, knew how to hold his own among people. He certainly wasn't unworldly. He was able to play the social game reasonably well and was generally well liked. Thus in time he managed to reach a certain balance between the insecure child, who would always remain within him, and the mature man, who continued along the path he had chosen with unceasing creativity and zest for his work.

He was driven, totally occupied by the process of working out his ideas, unable to tear himself away from it. During the laborious process of creating he often could not stand to have people around him. He spent most of his time in his studio like a modern hermit, not always an easy task for his closest relations. He was, in fact, aware of this and sometimes felt guilty about it, but he could not help it. Only when he had the little pieces of his puzzle all in place could he again pay attention to others and take interest

in them. He, too, knew the common human need to belong somewhere and have ties to a specific group, even, for example, the Rotary Club, which he joined in the second half of the 1950s. Usually he felt totally out of place there. He would get terribly frustrated, but he continued to go faithfully, an outsider who still wanted to belong.

While traveling, far from his studio, not occupied with the heavy task of having to give shape to a specific idea, he could relax much more and participate in social activities. That's why all his life he preferred sea voyages. The sea served as a kind of haven. During a trip by boat all need for concentration and self-discipline fell away from him. For a while there would be no reason to push himself harder, no longer any self-imposed obligation to "exceed his supposed boundaries." He could be completely relaxed and receptive to others, and in this mood he enjoyed a certain popularity. The following limerick is an amusing illustration of a side of Escher that is perhaps unexpected. He received it after a voyage by ship in 1960 as a parting gift from an elderly American lady who had been a fellow passenger:

> *A charming co-traveler Escher*
> *Has given us all so much plescher*
> *That the prospect of leaving*
> *Tomorrow is grieving*
> *Me to an unreasonable mescher*

As a beginning artist, Escher settled in Rome in the 1920s. Despite an almost complete lack of artistic and social success, this was a happy period in his life. He was in love with and happy with his wife, greatly devoted to the two small sons who were born one shortly after the other, attached to family and a circle of friends. The Italian landscape fascinated him. The joy of being engaged creatively and as a craftsman in the production of his prints dominated the never-ceasing monetary worries, at least as far as he was concerned. He had always been used to a sober life-style and, consequently, the extreme thriftiness that remained mandatory was not much of a problem for him. Perhaps to his wife it sometimes seemed to be stinginess.

After about ten years of hard work, some appreciation for what he was doing began to emerge in a small circle (see, among others, the words of praise from the critic G. J. Hoogewerff already quoted), but that appreciation produced few revenues. He earned hardly a nickel, as is evident from his notes. In 1933 (he was thirty-five years old at the time) the total sales of his work amounted to no more than 751 guilders, 577 guilders in 1935, and these were gross receipts, from which all expenses for materials still had to be subtracted. A somber picture from a material point of view, the only bright spot being that his parents and parents-in-law could assist financially. Still, during those happy Italian years, Escher remained at work full of courage and usually in a good mood.

In 1935 Escher felt it was necessary to leave Italy with his family because he saw the threat of Fascism there as becoming too serious. He settled in Château-d'Oex in Switzerland, where he was unable to work in his old, familiar style. He felt that he had reached a dead end by being uprooted, torn loose from his source of inspiration, the Italian landscape. He did continue working, but an essential change did not occur until the following year. He made a voyage by sea, and in Spain visited, among other sites, the Alhambra. There he was deeply impressed by the decorative art of the Moors, in which a plane was divided into figures that repeat themselves. What the Moorish artists had done with abstract figures Escher began to do, in 1936, with recognizable figures such as birds, fishes, and numerous other motifs. The artistic development of the ideas conceived in the Alhambra for regular division of planes was not accomplished very easily. On the contrary, it was an exciting and at the same time exhausting occupation. Days, and often also nights, were spent on the extremely difficult process of visualizing his "ideas." Searching and groping, he was on his way toward the new style that would later bring him world fame, but that for the moment kept him waiting. As a human being he fortunately found compensation in his family and his circle of friends, but as an artist he indeed "walked around all by himself" in his magic garden during those years. He walked around "head over heels in love" with the process in which he was engaged: the division of planes into congruent images that repeat themselves. Form and contraform. But he was lonelier than ever before. Nobody saw what he saw. He had not a single predecessor, nobody to encourage him or give him a helping hand. Other plastic artists greeted his efforts almost always with incomprehension, disdain, or even aversion. Thus it is no wonder that he continued to feel isolated, in the grip of the new process that had occupied him since 1936, unable and also unwilling to detach himself from it. The first positive reactions from art critics came only after a few years. The influential G. H. 's-Gravesande wrote in May, 1940: "He moves me. An exceptional graphic artist. Extremely surprising work, and one can't look at it enough. A miracle of cleverness."

Such critical acclaim was at first still an exception. In the financial area, success was also slow in coming. His earnings, which had fallen off to f.341 in 1937, amounted to f.1411 for the year 1939, f.1155 in 1941, and f.1408 in 1943. After the war there was a gradual improvement, but the big jump in earnings did not occur until 1954—the year of Escher's exhibition at the Stedelijk Museum in Amsterdam—when he made a total of f.16,776.

This bleak list of figures can be summarized in the following words: thirty years of poverty. They were able to keep going only thanks to the help of parents on both sides. For Escher, this understandably contributed to feelings of doubt about his abilities, the value of his work, and the wisdom of continuing the battle he was fighting with an unwilling medium in order to bring his ideas to reality. For himself—and for a few

interested people here and there—his work, of course, had value. But how was it regarded from an objective point of view? Why did the official art world remain so lukewarm? "You produce wallpaper," his father sometimes said. A joke? Or was this perhaps what others thought, too?

Sensitive as he was, he connected these feelings of being alone, of not being understood, of not being rightfully appreciated for his true merits, with similar feelings in his youth. Had he then, despite everything, also failed as an artist now that almost nobody seemed to want to understand the language he had learned through such a painstaking mental process? Didn't anybody want to speak the language that occupied him so completely? He felt wounded, hit in a weak spot, by this lack of understanding. The scar from that wound would always remain, even when wider circles arrived at an understanding of his work. Thus he wrote in 1955 that life is a school in which we exercise ourselves in loneliness. And in 1959, when he was past sixty: "I am beginning to speak a language that is understood by only very few. This makes my loneliness greater and greater."

"I'm walking around all by myself here." Escher described this loneliness as refreshing and oppressive in the De Roos Foundation's book of 1958, *The Regular Division of the Plane.* He experienced great satisfaction from his complete concentration on that new world of plane fillings. At the same time, however, he feared the loneliness that was its consequence. His creativity isolated him from his surroundings more than he liked.

In that same year, 1958, on October 12, in a letter to his eldest son, George, who had just immigrated with his wife to Canada, he wrote, among other things, the following:

Dear children:

Children, children, children. When you pronounce a word a few times in succession, you don't know what it means anymore. You then still hear only those funny Dutch sounds. . . .

Again and again the large flocks of starlings fly up out of the tops of the tall beech trees, circle around, and sit down again in another top. This quiet Sunday morning, mother and Arthur not yet gotten up, I see them circling past again and again, high above the window of my studio. They feel the fall migration coming, they are being called somewhere, their group consciousness is restless. . . .

These days I have great trouble accepting my fate when I think of you. That's why I have buried myself in sphere spirals. What can I say to them, what can I say to them? I never said anything to them when we talked, and now I have to do it in writing? There the starlings come again. In groups of 30 or 50 at a time they alight in the top of the tall beech tree, already partially defoliated, which stands at a diagonal behind the oak in

our garden. They all make the same soft little whistling sounds. The pope is dead. He is lying in a glass casket, just like Snow White. He is wearing red slippers with a cross embroidered on top and the Americans have fired a projectile that perhaps will never again return to earth. It sure is nice that for a change it isn't the Russians, even though it seems that the thing will bypass the moon, and that guy in the Hawaiian Islands will sit there like a fool with his button that he is supposed to press.

So we all play our own little game and none of us know why, not the starlings, not the comedians with their dress-up party for a dead man in Rome, not the conquerors of gravity in the United States, not you in the big city of Montreal, and I with my sphere spirals least of all. It is a sad business, but it is fascinating and remains so for the time being. . . .

This is a sad person writing. He misses his children a lot now that they are so far away. He has trouble with his health. There are difficulties at home. What is the meaning of life? Isn't it a sad business?

"I never said anything to them when we talked. . . ." We often get the impression that people in the world of Escher's experience remained somewhat on the periphery. They often made him insecure. He could give strangers the impression of being somewhat naive and awkward. He was not suited for "small talk." He himself couldn't do it because his self-criticism was too strong. When others did it, he saw through them mercilessly. He rejected familiarity. When a relationship didn't "click" for him, he kept people politely, but clearly, at a distance. This happened to everyone who did not have "something to say." Even making a portrait of a "stranger" cost him the greatest effort because in doing so he felt the distance between himself and the other person becoming too small. He was a master at this art, but the few portraits he made are of his parents, his wife, and one or two old and trusted friends. "My psyche isn't up to making a portrait," he once said. His self-confidence wasn't equal to the task of being close to someone physically and psychically.

In the letter we easily see through the bravado of the "lighthearted game." The author is getting older, the circle of trusted friends around him is thinning out, the oppressive loneliness is increasing. And in that sphere of somberness he turns to the harmony that for him emanates from the print on which he is working. As he said, "These days I have great trouble accepting my fate. . . . That's why I have buried myself in sphere spirals." Is the loneliness there perhaps less oppressive, or even refreshing? His pleasure ground is now a place of refuge for him. Crystallized emotion. A defense against the abandonment and uncertainty that torment him. Wishful thinking? He compares himself with the starlings in his garden. Those starlings don't know what they are doing. Well, he doesn't know that about himself either. Actually nobody knows, he tries to tell himself, but that does not console him. All told, "it is a 'sad business,' but it is fascinating . . . for the time being." Even the hint of optimism in the

word "fascinating" is partially taken back by his addition of "for the time being." In time he will see the world as "a hopeless case."

Even during the peak of his life, as a man in his fifties, Escher would sometimes be overtaken by the fear of having reached the end of his creativity. When he had once again worked out an entirely new idea in a print and completed it, he would ask himself desperately what was left for him to do. His studio was no longer the sunny place of his beginning years. He felt empty. New ideas stayed away and—being the perfectionist that he was—he was not satisfied with anything less than a new idea. Always again the fear of not knowing what to do now. And then, again and again, "doing that which you surmise to be too difficult for you." Wrestling during sleepless nights to arrive at the point of making a new idea visible. Then the relatively peaceful period of the technical execution. After it is finished, however, uneasiness returns: the feeling that the print, fixed on lithographic stone or on board made of pear-tree wood, has just missed being caught exactly the way it had appeared in his mind. So the vicious circle closed itself: fear of chaos, a ceaseless searching for ordering principles, catching these in an image that can be fixed on paper, discontent with the result obtained, uncertainty, distrust of appreciation by others, again an escape from reality, chaos. The lack of understanding he had experienced for years—in fact, since childhood—had hurt him so deeply that he could manage only with great difficulty, or not at all, to have faith in his own abilities and his own significance as an artist. Even in 1965, at that time certainly well known and celebrated everywhere, he said at the acceptance ceremony for the Hilversum Culture Prize that he felt embarrassed by the rating "artist."[3] He distanced himself from that concept. And finally even from his own works. In 1966 he could only with the greatest difficulty be restrained from destroying his artistic records. He thought it senseless to keep all that "mess."

Still his work had an enduring hold on him. Not a year went by that he didn't come up with something entirely new. The only exception was 1962. That year he had to undergo a serious operation, after which the rest of his life would become a true martyrdom from a physical point of view. Also during the last few years before his death in 1972 he no longer had the strength. The somewhat mysterious print *Snakes* of 1969 was his last.

"Abstractions that have nothing to do with reality. . . ." Escher could react quite sarcastically when once again someone announced that he had so "clearly" understood the symbolic meaning of one of the prints. No, his print *Reptiles* was not a striking illustration of the idea of reincarnation, he assured people during his lecture of October, 1964.[4] He had not hidden any moral or symbolism in that print! *You see only what you see.* This, or a similar remark, was steadfastly his reaction when asked about the meaning of a print or the symbolism contained therein. After such a remark, he used to switch quickly to another subject.

Now this is a rather strong way of putting it. Furthermore, quite a few statements and

indications by Escher himself point in another direction. As Escher himself said "about all of his work," there is more to it than just a "lighthearted game." In a private conversation he usually would admit this more readily than in public. For example, he stated openly to his friend and colleague the graphic artist Hans van Dokkum that he used graphic art *to give form to his ideas.* But he also said so even in public. For example, in 1965 in Hilversum, in the same acceptance speech in which he objected to the word "artist," he declared in no uncertain terms that there is a "testimony" in his prints. Rarely did he state in such clear language that we indeed may, and even must, see a deeper meaning in his work. And for this it is obvious that we must first of all look to his own writings.

In an article in the trade magazine *The Graphic Arts,* Escher writes about his discovery of dividing a plane into regular, congruent figures. Every line that separates these figures from one another has a double function; every line demarcates a figure on both sides. [5] This discovery, he says in his article, conveys not only great joy but also the sensation of approaching something that is primeval and eternal. "Primeval" and "eternal," joined together in one breath. It seems illogical. However, if we sample these two words in their mutual interdependence, then we perceive something of what he wanted to indicate: a groping for the secret of all existence. Thus much more than just the filling of a plane.

This same matter is discussed in the article "White-Gray-Black," [6] where he talks about the woodcutter who cuts away the black plane (the devil) until nothing is left but the white paper (God). When he adds, in parentheses, "possibly out of ethical-symbolic considerations," this is certainly not meant in an ironic sense. The ethical-symbolic was apparently not so far from his thinking after all.

On page 34 we read that the print *Verbum* contains a reference to the biblical story of creation. On page 37 we are again struck by the words "to symbolize" when Escher talks about his ball with fishes. With his print *Hand with Reflecting Sphere* he wants to show that every person is the center of his own world, and that this cannot be changed (page 60). Clearly it is Escher's intention that we see more in this print than just that hand holding a globe.

And then there is his longing to "approach infinity as purely and as closely as possible" (page 124). All the prints devoted to this in the last ten years of his life are necessarily symbolic in nature. The idea of endlessness represented on a piece of paper: where our eyes reach the border of the print, the imagination must assume the task of the eye.

On November 7, 1940, when Escher is forty-two years old, he jots down in his pocket agenda: "Last night I experienced flight in my dream." At the age of twenty-two he had had a similar experience, not in a dream but listening to an organ concert in the Bavo Church in Haarlem. In a letter to a friend he writes about it: "The organ increased quite a bit in size; the pipes reached from the heavens down to the earth, and the young

man felt such a strong wind that he stood up from the stone steps and flew into the sky right through the middle of the swaying columns."

Usually it is young children who experience flight in their dreams. Many of us may remember the feeling of floating in space detached from everything, free from the leaden ball of gravity, that feeling of lightness. It is a kind of childish experience of infinity. As we get older, our dreams acquire different content, and for most of us, unfortunately, this possibility of feeling detached and free is lost. Barring exceptions. Obviously as an adult Escher experienced once again that dream situation. It made such an impression on him that he remembered it upon awakening and jotted it down.

It seems that a relationship exists between that dream of being detached, of being free, and his longing to approach the idea of infinity as closely as possible. "Deep, deep infinity! Rest, dreaming . . . away toward unconsciousness."[7]

In his work he also sought that rest. He was convinced that with his print *Circle Limit III* he had succeeded in representing the idea of spatial infinity on the plane. Series of fishes swim by, following one another along a circular course from edge to edge. They arise at a ninety-degree angle from infinitely far away, like rockets out of the limitless space at the edge, and lose themselves there again. Not a single component ever reaches the boundary line. And outside of it is "absolute nothingness." Still, that "nothingness" is essential for this round world. It is so for two reasons. An "inside" presupposes an "outside." Furthermore, "outside" in that "nothingness" are located the immaterial, geometrically ordered centers of the circle arcs out of which the print is constructed.[8]

Infinity = rest = unconsciousness = to be detached and free. In *Circle Limit III*, Escher was able to find an adequate language of images to give shape to his emotional involvement with the idea of infinity. Here, too, it is valid that we may (and must) see more in this print than we are seeing. It wasn't primarily Escher's purpose to visualize a small segment of mathematics, to play a purely intellectual "game" of mathematical ordering. In a manner characteristic of Escher, intellect is here (and in many other "mathematical" prints) coupled with emotion. His ideal was to use the intellect in an emotional manner. Or the reverse: to make an emotion visible in a well-thought-out, intellectual way. The fact that by doing this he arrives in the sphere of mathematics does not mean this was his main purpose. In his prints he strove to express, by means of his language of images, his emotional as well as his rational bond with the ordering principles that dominate nature. In that ordering he sought his own harmony. The fact that mathematicians saw parallels in his work, representations of that in which they were themselves engaged, gave him great satisfaction, but it was not a mathematical impulse that spurred him to work. It was not Escher who discovered mathematics; the mathematicians discovered him and appropriated his work. He himself had no objections whatsoever. He was delighted and proud that his work apparently could lay a bridge between art and science. When the need arose, he made diligent use of the

information offered to him from the sphere of mathematics. However, he did write in his pocket calendar in 1950: "It is impossible to understand human beings well if one does not realize that mathematics germinates from the same root as poetry, that is, from the gift of the imagination" (from José Ortega y Gasset, *To Believe and To Think*).

It is sufficiently evident from the foregoing that the search for symbols in Escher's language of images is more legitimate than perhaps appears at first sight.

"I'm walking around all by myself here." To what extent is this loneliness that oppresses as well as refreshes expressed in his prints?

Escher himself would immediately have answered that question in a negative sense. "You only see what you see." However, it appears that this motto does not hold. We may definitely—with timidity and caution, of course—search for a deeper level of meaning in his works. He himself did not want to pause for this, but it is also not primarily the task of the artist. A plastic artist speaks a language of images. To translate that language into words is possible, even necessary, for the message to be well understood. The artist himself is not, in his capacity as artist, the most likely person to do this. To what extent does he know his own deepest stirrings? To what extent does each of us know our own?

We must quickly add that extreme caution is required for such a process of translation. The translator should be constantly aware of the danger of "the art of interpretation." He must remain prepared to keep open the possibility of differing translations, to test and perhaps accept them.

It is definitely not so that one can say about specific prints, "Look, here the artist has symbolized his feelings of loneliness." Or, "In this print, Escher has sought and found consolation for his walking around all by himself." It doesn't work so directly.

From the letter to his eldest son quoted above (see pages 145–46), Escher emerges as a sensitive, poetic human being. That poetic, even romantic, character trait will also strike the reader in other texts in this book, such as the two letters to Oey Tjeng Sit and the articles in *De Delver (The Digger)* and *De Grafische (The Graphic Arts)*. In fact, all of his writings reveal a sensitivity that the superficial observer of his prints wouldn't expect. How could such a person live without putting something of himself into what occupies him day and night? However, he keeps his emotions well under control. He "buries himself in sphere spirals." He deals with his emotions by way of his intellect. Crystallized emotion. No allegories or direct symbolic references (he would have found that too artificial), but an undercurrent permanently present in his work: the experience of loneliness and the need for support.

Escher's isolation is more than an individual emotion of which his prints are an individual expression. The realization of this leads to a better understanding and a deeper appreciation of Escher's language of images.

After what has been discussed, it almost goes without saying that a direct link exists between the enormous popularity of Escher's work and the hidden "message" that is present in it. With his prints he touches "sensitive strings" in the observer, who — mostly unconsciously — experiences something of an affinity with Escher's personality. With his loneliness.

Famous, respected, admired, loved in the circle of his family and friends. Superficially seen, Escher had little reason to complain about loneliness. However, there are other factors. First, the extremely laborious road he had to travel in his creative development, which forced him to isolation, sometimes even to the existence of a hermit. At the time he made his complaint he was certainly well known and popular. However, did people really know him, really understand him? Did people have any idea of the emotions and ideas that formed the basis of his work? Added to this was the loneliness that comes to everyone in the process of aging. For him this process was accompanied by health problems, problems at home, loss of people who were dear to him, and disappointment about what people were doing to him. The *Homo ludens* he wanted to be and remain was again and again roughly interrupted in his game. He suffered from the fact that, in his eyes, society was becoming more and more chaotic and formless and that true progress appeared to be a mirage. And all this while he could not live without order. One thing piled on top of another. He tried to free himself in his work, his last source of support.

This side of his personality appeals, unintentionally, to the person looking at his prints. For that viewer, it is not a conscious appeal. Escher's work offers us a wordless speech, a language of images. One feels that under that playful, moderating, technically clever representation more lies hidden. What exactly is this? One has trouble answering that. The fascination is there, but why really? Even with a print like his *Sphere Spirals*, which is a "dull" print at first sight, something is obviously going on. But what? Certainly not only the fact that Escher, witness his letter, has "buried himself in it"? Isn't it thus logical that viewers of his work express in such differing ways what they mean to see?

It is probably Escher's experience of isolation (which through many of his prints is transferred more or less unconsciously to the viewer) that accounts in part for the attraction to his work, although Escher himself was not aware of this. In his regular division of planes, see how the figures lie against one another without seams, without any contact. No, worse still, they are only one another's background. One another's condition for existence and one another's negation. The eye can only really "see" the one figure by completely ignoring the other contiguous figure. Escher's world of shapes is densely populated and at the same time empty, as in the print *Relativity*, where every mutual relationship is completely lacking. The figures appearing in this print by

definition don't even know about one another's existence. A worse condition is not possible: this is total loneliness.

With his cosmos, Escher holds up a mirror in which mutual alienation stares us in the face. The grimace is represented in such a way that it often comes across as less than serious, sometimes ironic, sometimes also sarcastic, but the reflection always takes hold of us. In his works, full of intentional layers of meaning, Escher has in his own willful manner also applied this *unintentional* layer of meaning, which elicits a feeling of recognition in us. Thanks to the technical perfection of his prints, the surprising inventiveness of his discoveries, his playfulness that is at the same time compulsion, the unintentional layer of meaning has a particularly strong impact. After all, don't we all ultimately walk around all by ourselves?

In Escher's language of images, our modern-day experience of isolation and aliena-tion finds expression, partly intentionally but mostly unintentionally, sometimes figura-tively, sometimes mathematically. On the other hand, he also built in his work, as he said himself, a home where it is good to dwell. In the incompleteness of his actual situation he knew that primeval, paradisiacal longing for an existence of order, of harmony, of being at home. The land of Utopia.

His love for the perfect form of things in nature, and in particular for the laws on which nature is based, dominated his thinking and feeling, and he testified to this, too, in his work. Thus it acquires a decidedly positive emanation, something encouraging, something affirmative. It is further strengthened by the inventiveness and playfulness with which it is offered, which is also to be found in his writings, as may become apparent from this book.

In his article in *De Delver (The Digger)* (page 84) he talks about the great joy he derives from the discovery of ever new motifs for plane fillings. In his article of September, 1951, in *De Grafisch (The Graphic Arts)* (page 16), he testifies to his joy and emotion when at night before falling asleep he thinks of that "ball of earth" floating through infinite space, illuminated by mother sun. He describes how he can be seized by a frightening, unreal, and at the same time blissful emotion when he feels himself standing eye to eye with the miracle of space, the miracle of three dimensions. And when he discusses perspective, he talks about our tyrant, gravity. Speechless with admiration, he observes that dictator, that perplexing and moving miracle (page 129).

In his text about regular division of planes he describes the graphic artist—himself— as a blackbird that sings in the top of a tree (page 90). He describes the joy that the graphic artist derives from repetition and multiplication. And he says that this joy is for him directly linked to the joy he derives from the process of repetition in all the marvelous, incomprehensible, splendid, enchanting laws that surround us (page 92). In his text about approaches to infinity he talks again about how breathtaking these laws

are (page 127). Again and again words fail him in his attempt to indicate that joy and express his feelings adequately. All of this betrays an emotional charge that also manifests itself in his graphic work, though in a typically Escher-like rational manner. This is unconsciously experienced by some, and recognized with a shock by others.

It is thus certainly very clear that Escher has experienced his loneliness not only as oppressive but also as refreshing. The refreshing aspect of this lonely tarrying in his pleasure ground emanates from his prints. At every turn he talks about wanting to testify in his prints that we live in a beautiful, ordered world. This does not have to be a ponderous testimony; often he does it in a very playful manner while making fun of our irrefutable certainties, as he puts it himself. Here, too, it is true that the originality of his themes and his astounding craftsmanship reinforce in a positive way the action of this clearly intentional layer of meaning. No wonder that so many experience something of it and, with the artist himself, also find comfort and a measure of shelter in his magic garden.

Escher's work testifies to the fact that things are not what they seem. Reality is affirmed as well as denied, objectified as well as made relative. That is why his world reveals itself in an atmosphere that is simultaneously cool and full of a tense strangeness. The viewer is both kept at a distance and emotionally engaged by it.

This ambiguity seems to fit miraculously well with the life experience of many people of our time. Escher bridges contrasts that many experience as complementary rather than as mutually exclusive. Without having specifically searched for this, he appears to have built a bridge from art to science. In the same manner — without having had this as a preconceived goal — he created a modification (and through this precisely a connection) of apparently mutually exclusive phenomena, with which he clarified the basic structure of our reality. That is why his rationally bizarre world is so familiar to us. It is not the world as we experience it in our daily lives. However, it is still our world, and, together with Escher, we feel at home in it.

Jan W. Vermeulen

[1] Escher, during an interview with Bibeb in *Vrij Nederland (Free Netherland)* in 1968: "His father he loved and admired. *He too was a lonely person.*"

[2] See page 21.

[3] See page 22.

[4] See page 47.

[5] See pages 83–84.

[6] See pages 17–18.

[7] See page 124.

[8] See pages 126–27.

# SELECTED BIBLIOGRAPHY

*Literature about Escher after 1950*

Bibeb, Interview with M.C. Escher, *Vrij Nederland*, April 20, 1968.

Bruno Ernst, *The Magic Mirror of M.C. Escher*, Amsterdam, 1976.

Albert Flocon, "At the Frontier of Graphic Art and Mathematics: Maurits Cornelis Escher," *Jardin des Arts*, 131, 1957.

Martin Gardner, "The Eerie Mathematical Art of M.C. Escher," *Scientific American*, vol. 214, April 1966.

E.H. Gombrich, "How to Read a Painting," *The Saturday Evening Post*, vol. 234, 30, 1961.

R. Hofstadter, *Gödel, Escher, Bach: An Eternal Golden Braid*, New York, 1979.

G.W. Locher, Maurits C. Escher, and Claude Lévi-Strauss ( . . . ), in jubilee collection for R.A.J. van Lier, 1981.

J.L. Locher et al., Catalogue of the Survey Exhibition in the Gemeentemuseum of The Hague, The Hague, 1968.

J.L. Locher et al., *The World of M.C. Escher*, New York, 1971.

J.L. Locher et al., *M.C. Escher: His Life and Complete Graphic Work*, New York, 1981.

H. Nemerov, "The Miraculous Transformations of M.C. Escher," *Artist's Proof*, 111, 2, 1963–64.

M.F. Severin, "The Dimensional Experiments of M.C. Escher," *The Studio*, 141, 1951.

Kenneth Wilkie, "The Weird World of Escher," *Holland Herald*, vol. 9, 1974.

*Writings by Escher*

*The Graphic Work of M.C. Escher*, Zwolle, 1959.

"How I As a Graphic Artist Came to Make Designs for Wall Decorations," *De Delver*, XIV, 6, 1941.

Introduction, M.C. Escher Catalogue, Stedelijk Museum, no. 118, Amsterdam, 1954.

*Newsletter of the Dutch Circle of Graphic Artists and Illustrators*, no. 3, June 1950, pp. 5–7, 19–20; no. 5, December 1950, pp. 4–7.

"Dutch Graphic Artists Talk About Their Work II," *Phoenix*, II, 4, 1947.

*The World of Black And White*, Amsterdam, 1959.

*The Regular Division of the Plane*, Utrecht, 1958.

Samuel Jessurun de Mesquita, Catalogue of the Exhibition S. J. de Mesquita and Mendes da Costa, Stedelijk Museum, Amsterdam, 1946.

"White-Gray-Black," *De Grafische (The Graphic Arts)*, no. 13, September 1951, pp. 8–10; no. 20, November 1953, pp. 7–10; no. 24, February 1956, pp. 14–15, 15–17.

Rudolf Escher and M.C. Escher, *Movement and Metamorphoses. An Exchange of Letters*. With an Introduction by L.D. Couprie, Amsterdam, 1985.

# LIST OF ILLUSTRATIONS

Unless otherwise indicated, all works are by M. C. Escher.

Page 37:
*Symmetry Work 20.* 1938. Ink, pencil, and watercolor, 9 × 9½″. Collection Haags Gemeentemuseum, The Hague
*Carved Beechwood Ball with Fish.* 1940. Beechwood, diameter 5½″. Collection Haags Gemeentemuseum, The Hague

Page 38:
*Symmetry Work 85.* 1952. Ink, pencil, and watercolor, 12 × 9″. Private Collection
Masatoshi (Japanese netsuke carver). *Three Elements.* 1962. Ivory, diameter c.2″. Collection, C. V. S. Roosevelt, National Gallery of Art, Washington, D.C.

Page 39:
*Development II.* 1939. Woodcut, 17⅞ × 17⅞″
*Path of Life I.* 1958. Woodcut, 16⅛ × 16⅛″

Page 40:
*Whirlpools.* 1957. Wood engraving and woodcut, 17¼ × 9¼″
*Sphere Surface with Fish.* 1958. Woodcut, 13⅜ × 13⅜″

Page 41:
*Smaller and Smaller.* 1956. Wood engraving and woodcut, 15 × 15″
*Square Limit.* 1964. Woodcut, 13⅜ × 13⅜″

Page 42:
*Symmetry Work 45.* 1941. Ink, colored pencil, and gouache, 9⅝ × 9½″. Collection Haags Gemeentemuseum, The Hague
*Circle Limit IV.* 1960. Woodcut, diameter 16⅜″

Page 43:
*Symmetry Works 122 and 123.* 1964. Ink, pencil, and watercolor, each 5⅞ × 8¼″. Collection Haags Gemeentemuseum, The Hague
*Circle Limit III.* 1959. Woodcut, diameter 16⅜″

Page 44:
*Symmetry Work 21.* 1938. Ink, pencil, and watercolor, 13 × 9½″. Collection Charles and Evelyn Kramer, Israel Museum, Jerusalem
*Cycle.* 1938. Lithograph, 18¾ × 11″

Page 45:
*Symmetry Work 66.* 1945. Ink and watercolor, 6¾ × 11″. Collection Dr. Stephen R. Turner
*Magic Mirror.* 1946. Lithograph, 11 × 17½″

Page 46:
*Symmetry Work 63.* 1944. Ink, pencil, and gouache, 7⅛ × 11¼″. Collection Haags Gemeentemuseum, The Hague
*Encounter.* 1944. Lithograph, 13½ × 18¼″

Page 47:
*Symmetry Work 25.* 1939. Ink, pencil, and watercolor, 9⅝ × 9⅝″. Collection Haags Gemeentemuseum, The Hague
*Reptiles.* 1943. Lithograph, 13⅛ × 15⅛″

Pages 48, 49, 50, 51, 52, 53:
*Metamorphose II.* 1939–40. Woodcut, 7½ × 153⅜″

Page 55:
*Castrovalva.* 1930. Lithograph, 20⅞ × 16⅝″
*Inside St. Peter's.* 1935. Wood engraving, 9⅜ × 12½″

Page 56:
*The Bridge.* 1930. Lithograph, 21⅛ × 14⅞″
*Dream.* 1935. Wood engraving, 12⅝ × 9½″

Page 57:
*Cubic Space Filling.* 1952. Lithograph, 10½ × 10½″
*Depth.* 1955. Wood engraving and woodcut, 12⅝ × 9″

Page 58:
*Puddle.* 1952. Woodcut, 9½ × 12½″
*Three Worlds.* 1955. Lithograph, 14¼ × 9¾″

Page 59:
*Rippled Surface.* 1950. Linoleum cut and woodcut, 10¼ × 12⅝″
*Still Life with Reflecting Sphere.* 1934. Lithograph, 11¼ × 12⅞″

Page 60:
*Hand with Reflecting Sphere.* 1935. Lithograph, 12½ × 8⅜″
*Three Spheres II.* 1946. Lithograph, 10⅝ × 18¼″

Page 61:
*Dewdrop.* 1948. Mezzotint, 7 × 9⅝″
*Eye.* 1946. Mezzotint, 5½ × 7¾″

Page 62:
*Spirals.* 1953. Wood engraving, 10⅝ × 13⅛″
*Sphere Spirals.* 1958. Woodcut, diameter 12⅝″

Page 105:
*Regular Division of the Plane II.* 1957. Woodcut,
9½ × 7⅛"

Page 108:
*Figure 1.* Illustration from *The Regular Division of the Plane,* 1958
*Figure 2.* Illustration from *The Regular Division of the Plane,* 1958

Page 110:
*Regular Division of the Plane III.* 1957. Woodcut,
9½ × 7⅛"

Page 111:
*Regular Division of the Plane IV.* 1957. Woodcut,
9½ × 7⅛"

Page 113:
*Regular Division of the Plane V.* 1957. Woodcut,
9½ × 7⅛"

Page 115:
*Design Fragment*

Page 116:
*Figure 3.* Illustration from *The Regular Division of the Plane,* 1958

Page 117:
*Regular Division of the Plane VI.* 1957. Woodcut,
9½ × 7⅛"

Page 121:
*Figure 4.* Illustration from *The Regular Division of the Plane,* 1958

Page 126:
*Circle Limit I.* 1958. Woodcut, diameter 16½"
*Circle Limit II.* 1959. Woodcut, diameter 16⅜"

Pages 130, 131, 132, 133:
Sketches probably made by M. C. Escher to illustrate his lectures on perspective